Kingdom of
Sand and Cement

Peter Bogaczewicz

Foreword by Edward Burtynsky
Essays by Karen Elliott House and Rodrigo Orrantia

Daylight

Foreword

Photographs take us to places unlike any other medium. Gazing into the images of Peter Bogaczewicz we are transported to a relatively isolated part of our planet, a place where by virtue of the gifts of the Earth people live an extraordinary and fortunate life. In seeing the world the Saudis have constructed for themselves and the marks they have left behind we are able to form a deeper understanding of their values.

Since the invention of the medium, photographers have lugged bulky cameras to remote corners of the earth in order to return with telling moments of their sojourn. In fact, we often define the past through these frozen fragments of time and arguably perceive more information through photographs than words or drawings could ever provide. There are many such predecessors: Francis Frith, Carleton Watkins, Samuel Bourne, and Walker Evans to name just a few, who have charted their journeys through the medium of the photographic image and made our understanding of the world richer for their efforts. In such a way, Peter has given us a privileged front-row seat to a chapter in the life of contemporary Saudi Arabia.

Not that long ago the inhabitants of Saudi Arabia were a nomadic desert people. The discovery of oil and the creation of Saudi Aramco, where the oil tycoon J. Paul Getty served as an accelerant, propelled this nation towards a wealth and prosperity unrivaled in the world. Over the past 40 years the Ghawar oil field alone has contributed five million barrels per day to feed thirsty tanks of trucks, planes, trains, and automobiles with the lowest-cost fuel on the planet. Easy money in Saudi Arabia has created a vast socioeconomic dependency controlled by few powerful hands. The world that is being shown to us through these images is created at the direction, discretion, and whim of those powerful hands.

Bogaczewicz has pried open a crack, allowing us to peer into this ultra-wealthy hermit kingdom, and through bearing witness with his camera we are offered a glimpse into what this previously nomadic culture is up to. With his background as an architect he finds a path that leads him through the fragile, historic abandoned sites that are yielding to time and the elements. We find ourselves looking at the hyper-speed modernization of an ancient culture—massive infrastructure projects, glimmering glass and steel towers on the horizon, luxury shopping centers, and brand new suburbs provided to a growing middle class.

Through Peter's lens we are given access to the evolution of an ancient culture, and its transformation into a contemporary landscape both in its architecture and its revision of cultural mores. However, the new Arabian edifices are poorly suited to the intense heat of the land, and exist in stark juxtaposition to the country's fragile historic sites and a disappearing way of life. Instead they co-exist with discarded plastics, tires, and refuse accumulating in the creases of both city and countryside. In his eloquent images, Peter Bogaczewicz continually returns to the built environment, and a reborn country that still appears on its surface like a backdrop to a uniquely privileged life, but is not exempt from the familiar and inevitable modern dichotomy of growth versus waste.

—Edward Burtynsky

Saudi Arabia: Tradition and Transition

The Kingdom of Saudi Arabia is in the process of profound change. It has gone from camels to cars and from mud houses to skyscrapers in the course of only seven decades. And today, under the forceful direction of a thirty-three-year-old Crown Prince, is seeking to transform its society and economy to mesh with the modern world.

Perhaps it is not surprising that the Kingdom, despite more than a millennium of history, has shown little interest in preserving vestiges of its rudimentary past, much of which lies in ruins. Similarly, the modern skyscrapers that now dominate its urban skylines often sit adjacent to pools of fetid water or piles of discarded debris. Typically, neither the Kingdom's past nor its present were well tended. Even the desert dunes, which Saudis continue to seek out and enjoy at every opportunity, aren't spared strewn garbage, plastic water bottles, and old tires. Only belatedly and recently is this changing as young, environmentally-conscious Saudis, for instance, organize dives to clear the Red Sea of garbage.

These contrasts and paradoxes are illustrated through the camera lens of photographer Peter Bogaczewicz, who has spent years traveling the Kingdom to capture its past, its present, and its people. Also an architect, he tends to focus on what he labels the transition from "sand to cement" in this photo documentary. Surrounding the sand and cement is a history and culture both ancient and unique.

Saudi Arabia is a sprawling nation nearly three times the size of Texas. Its early history isn't well recorded. Even its most famous city, Makkah, isn't mentioned in any ancient literature until 741, well after the death of Prophet Muhammad, who made Makkah the center of Islam, the sacred religion the Angel Gabriel revealed to him in oral recitations over two decades, up to his death in 632. In the Prophet's time—as before and since—Arabia was a sparsely settled region dominated by warring tribes who often raided each other to survive. Muhammad sought to end this strife by preaching that all believers must transfer obedience from their tribal chief to Allah if they wanted one day to trade the tribal travails of this life for Allah's Paradise. His message took. Within a century, Arab converts working together spread Islam from Persia through the Mideast to North Africa and later Spain.

Just over a millennium later, that precise message was adopted by the House of Saud to seize power in Arabia, founding a dynasty that has ruled—with only two brief interruptions—since 1744. Muhammad ibn Saud, a tribal leader dwelling in Diriyah, a mud village near modern Riyadh, teamed up with Muhammad ibn Abdul Wahhab, a fundamentalist zealot seeking to restore Arabia to the purity of Prophet Muhammad's time. That old mud village, which through the last century lay largely in ruins, has been extensively and expensively restored since 2011 by the Saudi government and now boasts a walled palace and helipad for Saudi King Salman. Below, on a broad plain, are numerous restaurants and wide expanses of green grass where ordinary Saudis and visitors can stroll or picnic.

For the Al Saud, preservation of its power, not Saudi history, has long been the priority. As a result, the social contract traditionally required citizen loyalty in exchange for whatever meager subsistence the monarchy could provide. "Hoarded money does no good," King Abdul Aziz, founder of the modern Kingdom of Saudi Arabia in 1932, told his ministers. "In peace I give all, even this cloak, to anyone who may need it. In war, I ask and my people give all they have to me."

Until oil was discovered in Saudi Arabia in 1938, King Abdul Aziz, like previous rulers, had little to share other than small revenues from Muslims making the Hajj, or pilgrimage, to Makkah, or subsidies from Great Britain, which sought to buy his loyalty to shore up British dominance in the Mideast. All that changed when the Americans discovered oil beneath the Saudi sands. As oil wealth ballooned, especially after the Saudi-led oil embargo in 1973 quadrupled prices, the sons of Abdul Aziz, who have ruled since his death in 1953, built modern skyscrapers and began to provide a cradle-to-grave lifestyle for Saudis: free health care, education, and government jobs. As a result, the past half century has seen a mass migration of Saudis from their tents and mud houses spread across the distant sands of Saudi Arabia to half a dozen major urban "cement" centers. Only 17 percent of Saudis live in rural areas compared with nearly 70 percent half a century ago. At the same time, dependence on government has grown with some 80 percent of household income in the Kingdom derived from government largesse.

This comfortable government cloak has allowed many Saudis to move through recent decades of incredible physical changes all around them almost as if sleepwalking. Traditionally, Al Saud monarchs haven't ruled by fear but rather by offering blandishments to secure their people's cooperation. Most every important decision is made by government; virtually every major need is provided by government. So, Saudi citizens need simply to go along. A vote on major political or economic decisions isn't possible. However, in 2000, the late King Fahd established a Majlis Ash-Shura, or consultative assembly. Its 150 members, appointed to four-year terms by the King, now include thirty females. This at least allows for public discussion of some issues, though decisions of the Majlis Ash-Shura are only advisory, not binding for the monarch. Thus, personal responsibility and personal initiative haven't been necessary or really welcome in Saudi Arabia.

For all these reasons, Saudi Arabia for the past half century has been much like a silent film featuring the flickering faces of one octogenarian ruler after another. Each was seen but not heard because preservation, not change, was their purpose. Now, under the leadership of Crown Prince Mohammed bin Salman, the Kingdom has suddenly become an IMAX movie on fast forward.

With oil revenue no longer capable of funding the sedentary lifestyle to which Saudis are accustomed, the Crown Prince is writing, directing, and starring in a new larger than life thriller unfolding in Saudi Arabia. In a country where for nearly 300 years the Al Saud and their Wahhabi co-religionists sought to keep Saudis emulating as close as possible the seventh century life of the Prophet Muhammad, Crown Prince Mohammed now seeks to wrench his quiescent populace into the twenty-first century. He is demanding Saudis play an active supporting role in his new production—Saudi Vision 2030. Saudi Vision 2030 is a futuristic script produced by the young prince with the help of $1.3 billion spent on international consultants. It calls for nothing short of a societal revolution to modernize not just the skyline but also the Saudi people.

Out with dependence on government jobs and in with self-reliance. Out with intolerant anti-modernist Wahhabi dogma and in with moderation. "Our vision is a tolerant country with Islam as its constitution and moderation as its method," he said unveiling Saudi Vision 2030 in 2016. Since then, the Crown Prince has gone well beyond enunciating high-minded platitudes about moderation and modernization.

He has handcuffed the Kingdom's religious police, who long roamed streets forcing women to wear the veil and terrorizing young people who violated strict gender segregation rules. These bearded men can no longer arrest Saudi citizens. Women are working in increasing numbers, allowed to start a business

without permission of a male guardian, permitted to join the military, and permitted to drive. Cinemas are reopening after a forty-year ban. Concerts and other entertainment long forbidden in public are now encouraged and subsidized by government with men and women allowed to mix. Late in 2018, the Kingdom hosted an electric car race where both men and women were allowed to compete. All this has been popular with young Saudis: some 65 percent of the populace is under thirty years of age.

The Crown Prince went further than upending religious taboos. He took on his royal relatives, jailing powerful princes, ministers, and businessmen in the Riyadh Ritz-Carlton Hotel and accusing them of corruption. Most were freed, but only after agreeing to return billions of dollars to the government. All this, the Crown Prince said, was intended to underscore that no Saudi is above the law. But the Saudi people understood a far larger message: the Crown Prince is absolute ruler. That message was underscored by the crushing of dissent in the Kingdom and by the October 2018 murder of Jamal Khashoggi, a Saudi columnist for *The Washington Post*. While the Crown Prince insists he played no role in the Khashoggi murder, it is clear that the tradition of all previous Saudi rulers of leading through building a consensus among key members of the ruling Al Saud family is over. Crown Prince Mohammed, a decisive risk-taker, has left no doubt that in the dangerous Middle East, he intends to act quickly if necessary—and entirely on his own.

Clearly this is a watershed moment for Saudi Arabia. The old silent movie is irretrievably broken. The Crown Prince's ambitious agenda to wean the Saudi economy off diminishing oil revenues and create a modern, high-tech economy in which Saudis rely on themselves for jobs in the private sector rather than government handouts, is a gargantuan challenge. Whether he fails miserably or succeeds dramatically—or more realistically something in between—his leadership changes everything in Saudi Arabia.

One huge change: this largely closed Kingdom is now opening its doors to foreigners as it seeks to build a massive tourism industry to substantially compensate for diminishing oil revenues. The Kingdom now grants e-Visas within minutes to foreigners who clear the Ministry of Interior's security data base and buy entry to a specific entertainment event. Tourist visas to enter and explore the country remain only a promise, though the Saudi Tourism Commission insists they will be available by the end of 2019. The Crown Prince sees a thriving tourism industry as not only a way to create jobs for young Saudis, but also to keep Saudis at home who now spend annually an estimated $25 billion vacationing outside the Kingdom. Six Flags is looking at building a park near Riyadh, and Disney, too, is considering entering the Kingdom.

More important, the Saudi government at last is getting serious about preserving and promoting ancient sites like Al-Ula and Mada'in Saleh, photographs of which appear in this book. Mada'in Saleh is an archeological site with remains dating from the first century Nabatean Kingdom and is the largest Nabatean settlement after Petra in Jordan. The Crown Prince himself took time on a visit there to pause his dirt bike and pose for selfies with Saudi tourists. Previously, the monarchy tended to preserve only sites made famous by the Al Saud such as Fort Masmak, an old mud fort in Riyadh conquered by Abdul Aziz in 1902 as he began his thirty-year war to once again subjugate Arabia to the Al Saud who had lost power in 1891.

Peter Bogaczewicz's artful and striking photographs of Saudi people and places capture the Kingdom's past and present even as the Crown Prince seeks to dramatically change its future. If he succeeds at preserving the Kingdom's stability, he could rule a half century or more. That far into the future it's impossible to predict what a modern Saudi Arabia will look like.

—Karen Elliott House

Spaces of Memory and Imagination

There are several ways of approaching the photographs in this book. They can be read as historical documents, as social observation, or more subtly they can be seen as a stage, a space of memory and imagination. There is an essential tension between them: memory represented by the timeless landscape of the desert and the ruins of the history of its settlement that seem to have risen and now dissolve back into it, and imagination, represented by the new infrastructure and high-rise development that seem to have landed abruptly on it.

Peter Bogaczewicz's images further accentuate this idea of a stage. His work as an architect has evidently sharpened his eye; his images are rigorously composed, every element aligned on an invisible grid of perpendicular lines. Buildings and mountains appear flat against the open desert sky, creating a sense of distance and detachment. His attention to the process of photographing architecture imbues the images with a certain gravity, a type of silence that is key to allow the drama between memory and imagination to unfold.

Kingdom of Sand and Cement was an opportunity for Bogaczewicz to develop interests one can see formulating in his earlier projects *Layers of a City* (2010–2013) and *Shore Road* (2011–2015). Throughout his work, consistent attention is paid to the expressive potential of the built environment. In *Shore Road* he focuses on the maritime character of Nova Scotia; in *Layers of a City* he deals with the complexities of a metropolis through the development of Toronto. In both series one can sense a preoccupation with how industrial and large-scale development can alter and eventually replace history and a sense of place. Traveling from his Canadian home to Saudi Arabia, he found himself confronted with this dichotomy at a colossal scale.

Being interested in photography of ruined architecture, I am aware of the dangers and pitfalls associated with it, especially the romantic representation of a distant past. In this work however, there is a respectful distance that doesn't take sides. It is for the viewer to allow the stage to be filled with the memories hinted by the petroglyphs, the abandoned mud houses, and the old forts full of decorated walls and pillars.

And then there we see the appearance of the modern infrastructure, the high-rises and ambitious development. It is the realization of a desired vision of a future against the fading presence of what once existed. For me this is a universal story, one that reaches beyond the borders of the Saudi desert, but here it appears amplified. It is perhaps Bogaczewicz's masterful use of scale that shows the magnitude of this invasion, new roads and buildings razing whatever stands in their way. Images like *Expansion of the Al Haram Mosque. Makkah* and *Eastern Ring Road bridge. Wadi Hanifah tributary* are good examples of this epic story, in his words recounting, "the conflicts and contradictions of the Saudi society."

One of the images in this series has especially caught my eye. *Family picnic under bridge. Wadi Hanifah* has a particular timelessness, at the same time being incredibly contemporary. The scene has been around for millennia, a family sitting on the sand of the desert, having a meal together. One could think of the Orientalist painters of the nineteenth century, the many studies of nomad life by Eugène Girardet come to mind. In this case there are no camels but an old car that lies parked a few steps from where they are sitting. They appear to be oblivious to the fact that the whole world has changed around them. An imposing concrete column supports a road that covers the sky. The desert itself has

changed, it is now a wasteland of urban detritus—their space of leisure cleared in the middle of rusting corrugated hoarding—all as if signaling that there's a price to pay for modernity.

As an art historian, especially one interested in the history of photography, I am excited by the connections between the images in this book and other photographs of the same places and landmarks taken in different moments in time. These coincidences offer the possibility of a dialogue across time, one which can unveil the underlying narratives of the past and present.

A conversation with Peter about this prompted him to show me a series of photographs by German Orientalist Bernhard Moritz shot in what is now Saudi Arabia at the turn of the twentieth century. His images of the Mina Tent City and Al Haram Mosque at Makkah taken just over one hundred years ago attest to the original spirit of the place. They are a step removed from the romanticized landscapes in Girardet's paintings, perhaps more faithfully upholding a connection with the past through the camera's depiction of place and architecture. One can see traditional nomad buildings like the hundreds of tents across the pilgrim camp in Mina, but also get an accurate sense of the scale and elegant style of the low-rise buildings surrounding Al Haram Mosque.

Although Peter's image of Kaaba is essentially taken from the same angle—only closer—everything around the solemn building seems to have changed. As with *Family picnic under bridge. Wadi Hanifah*, the people in this scene are absorbed in their prayers and thoughts, oblivious to the history around the Mosque that had recently vanished, replaced by colossal blocks clad in glass. Behind them loom dozens of construction cranes, the heralds of further development to come.

As we immerse ourselves in this particular vision of the Saudi Kingdom, there is an element that grounds us back to reality. Living in and working from Riyadh, he has been able to engage

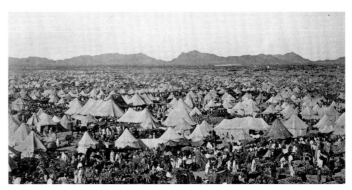

Camp of the Pilgrims on the Plains near Arafat. Bernhard Moritz, 1916.

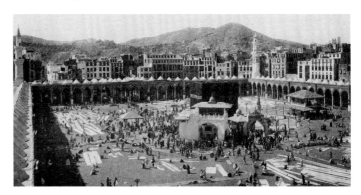

Al Haram Mosque from the East Minaret in Makkah. Bernhard Moritz, 1916.

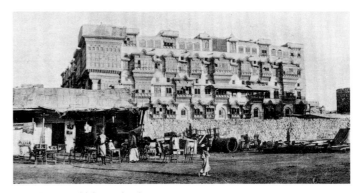

West Gate in Jeddah. Bernhard Moritz, 1914.

with local people who straddle the clash between the old and the new. The series of portraits included in *Kingdom of Sand and Cement* give us another way of relating to these uncanny spaces.

His journey starts with very wide and distant shots, gradually homing in until we find him up close and personal with the inhabitants of the desert. What we see through his lens yet again represents the confrontation between past and future, the essential conflict at the heart of his project. We see humble people—workers on their way back home, and a camel owner with his daily companion—posing unassumingly for their portraits. But we are also shown gleams of another world, one much more sophisticated and luxurious. From the streets of the cities we are brought in to the lavish interiors of the new hotels, a dreamy contrast to some of the realities.

One final element present throughout the series is the idea of nature. It is reading these images as the evidence of a relationship with nature that one can bring the play to a close. We see the old mud houses crumbling down into the desert, and we see traces of ancestral civilizations on the petroglyphs found in rocks and caves. And then through Bogaczewicz's eyes we see modern development framed by mountains of discarded tires, plastic bottles, and construction debris. There is a shift from a reliance on a predominantly natural landscape to an urbanized environment: contemporary and imposing. In this sense *Kingdom of Sand and Cement* hides an inevitable premonition, that this vision for a future, if not managed, may likewise become a memory as cement erodes back into sand.

—Rodrigo Orrantia

Prologue

Wadi Faihiq. Tuwaiq escarpment.

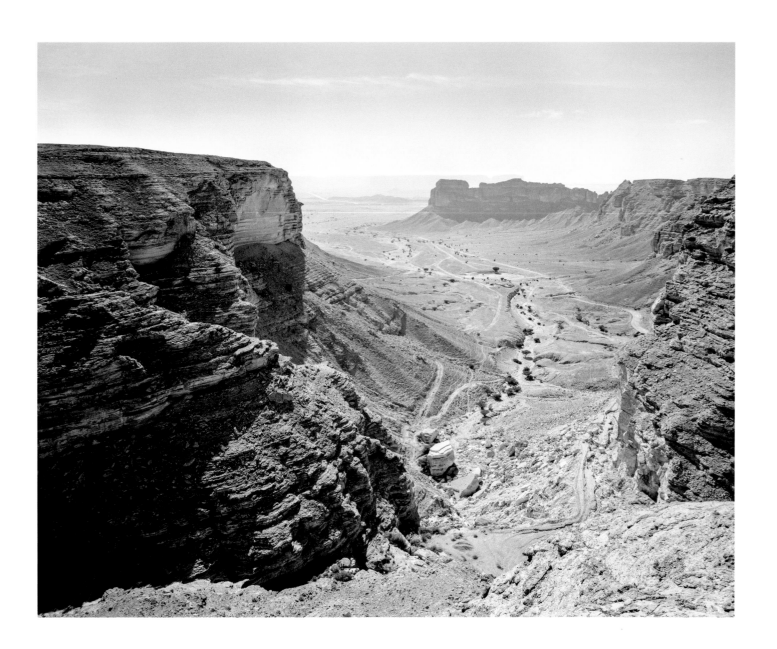

Tombs near Mount Ethlib. Mada'in Saleh.

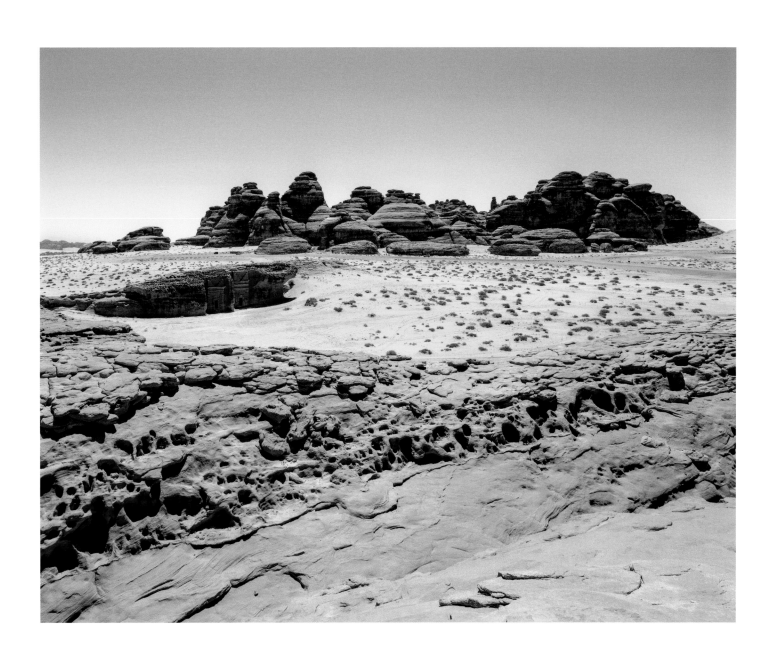

Petroglyphs. Ad-Dahna desert.

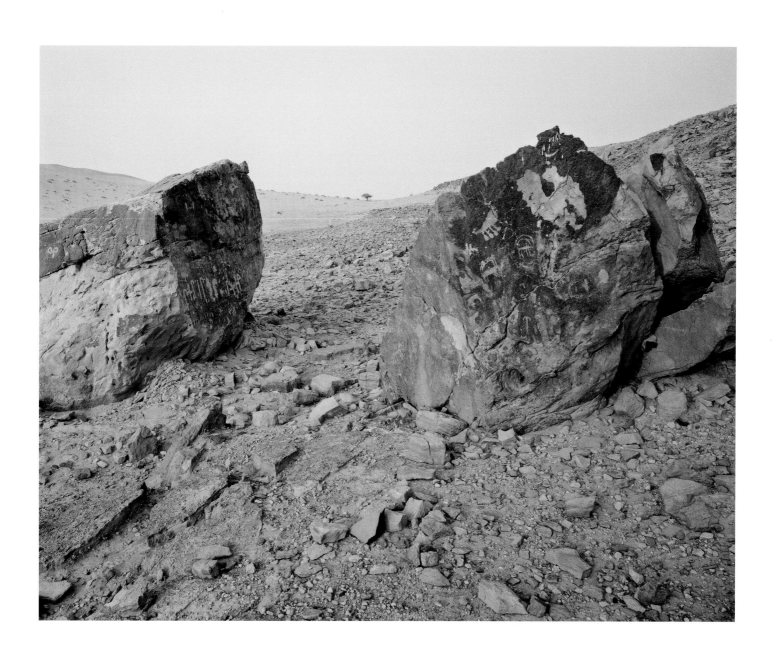

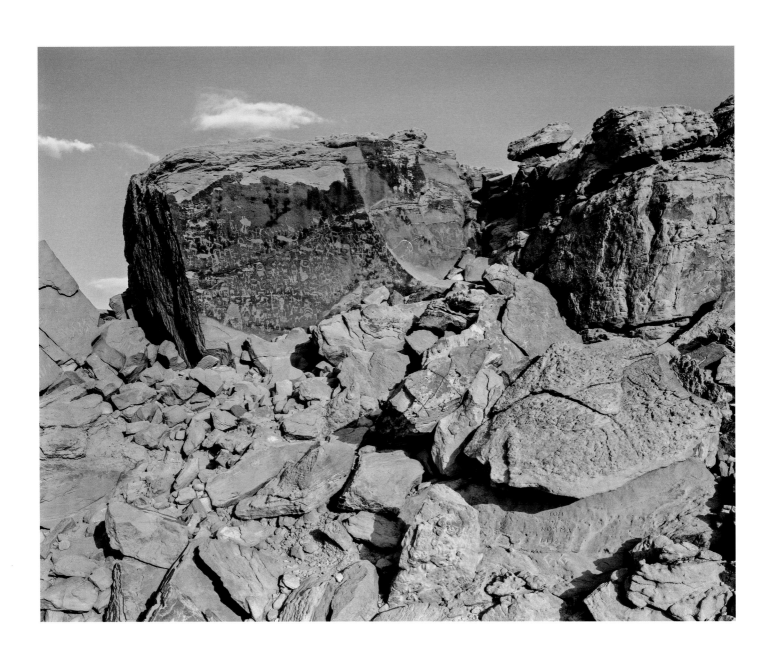

Petroglyphs. Riyadh region.

Petroglyphs. Jubbah.

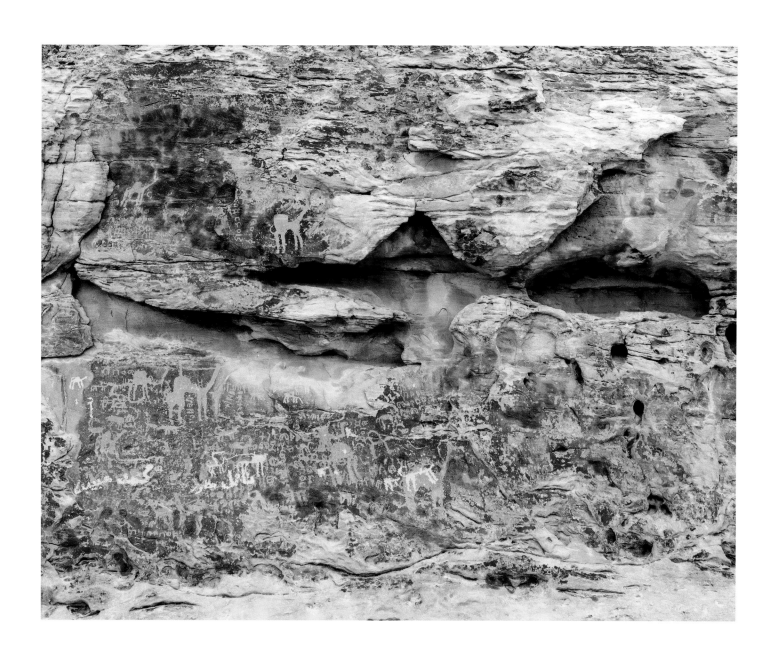

Mada'in Saleh. Madinah region.

24

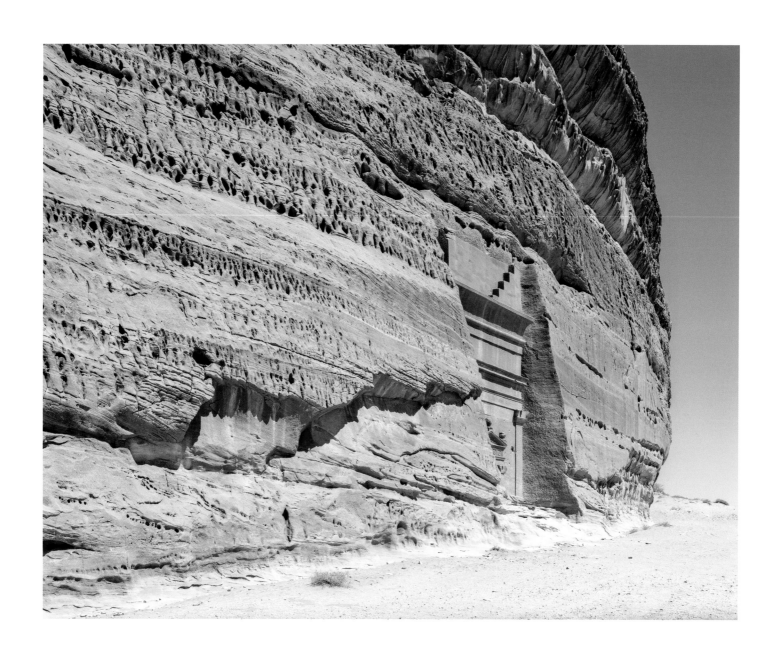

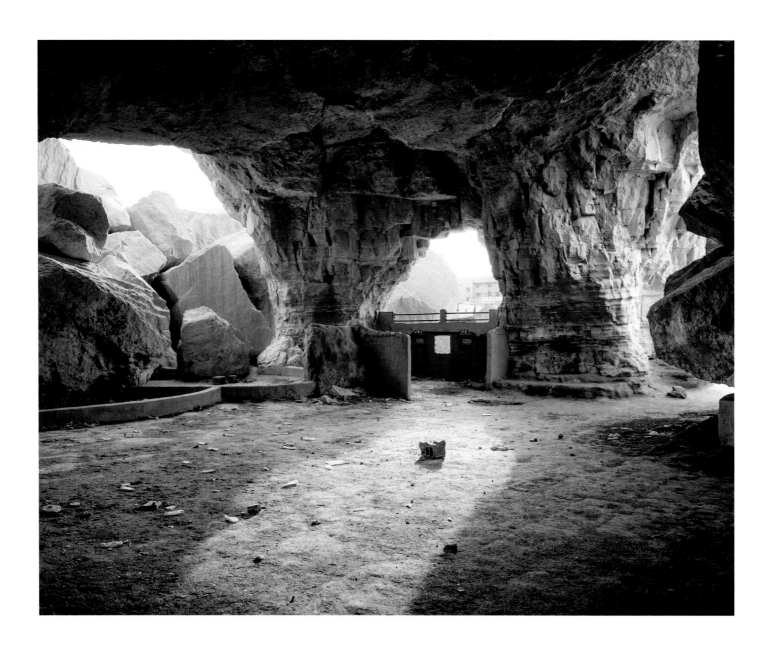

Al Qarah Mountain caves. Al Hofuf.

Camel trail. Tuwaiq escarpment.

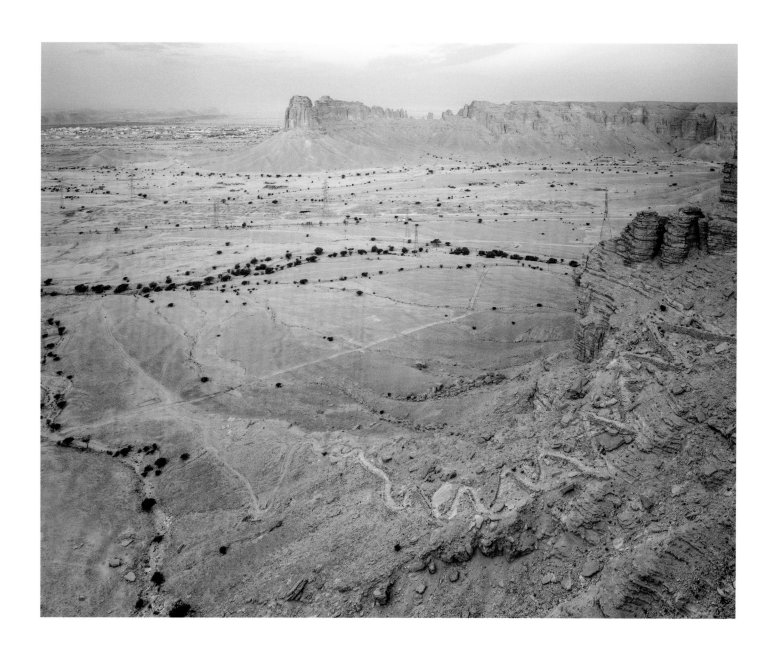

From Sand To Sand

Abandoned settlement. Ushaiqer.

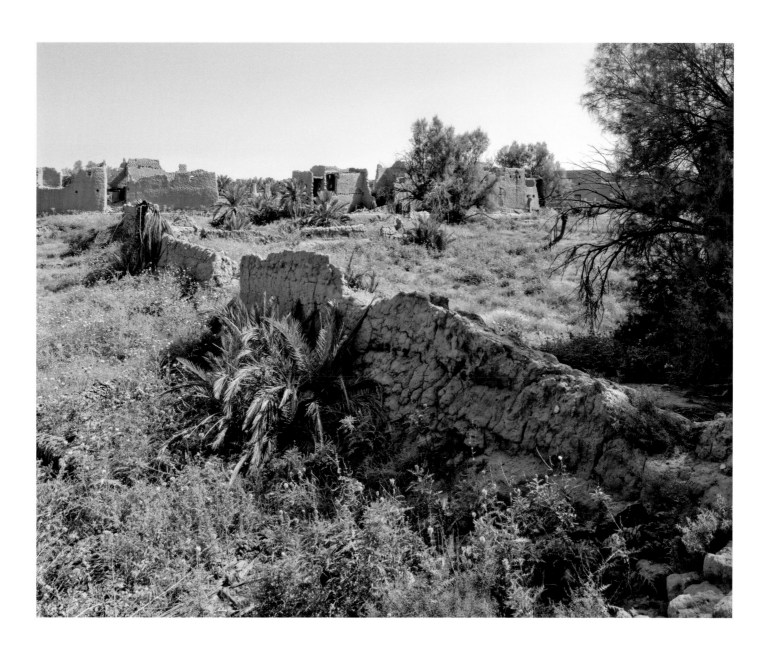

Abandoned settlement. Khaybar.

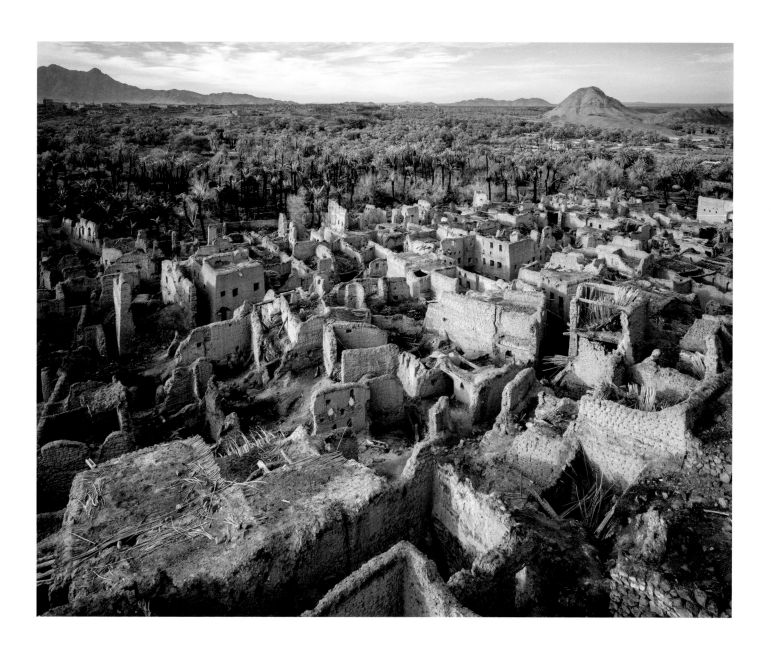

Old and new town. Al-Ula.

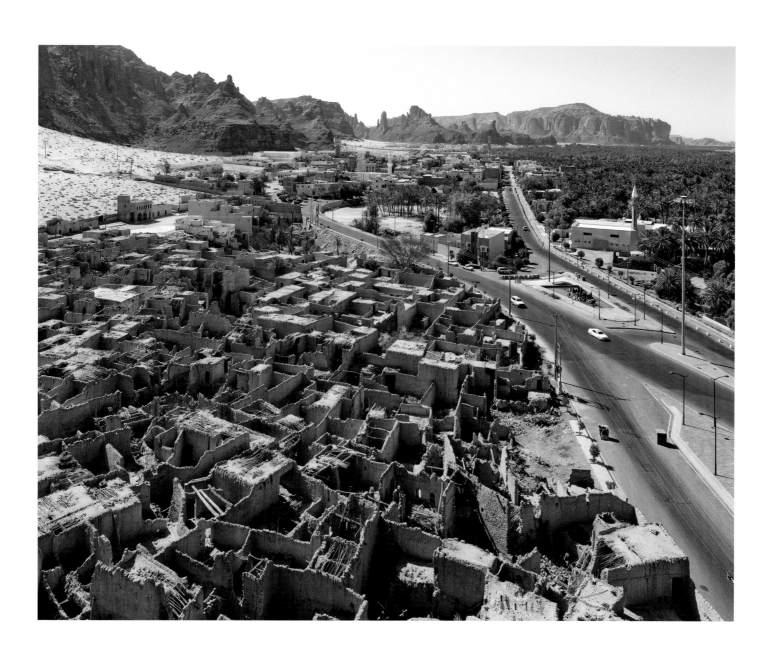

Abandoned mud building. Dirah.

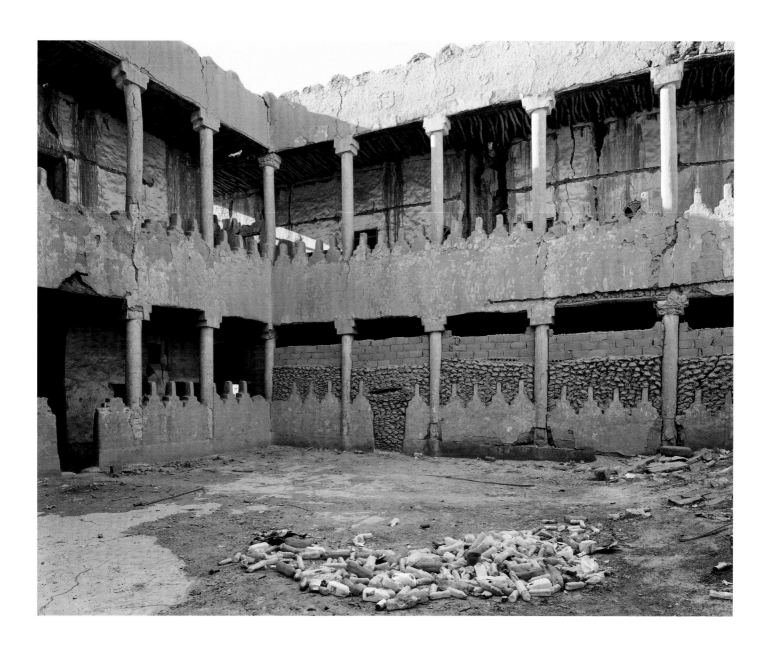

Mud house interior. Marat.

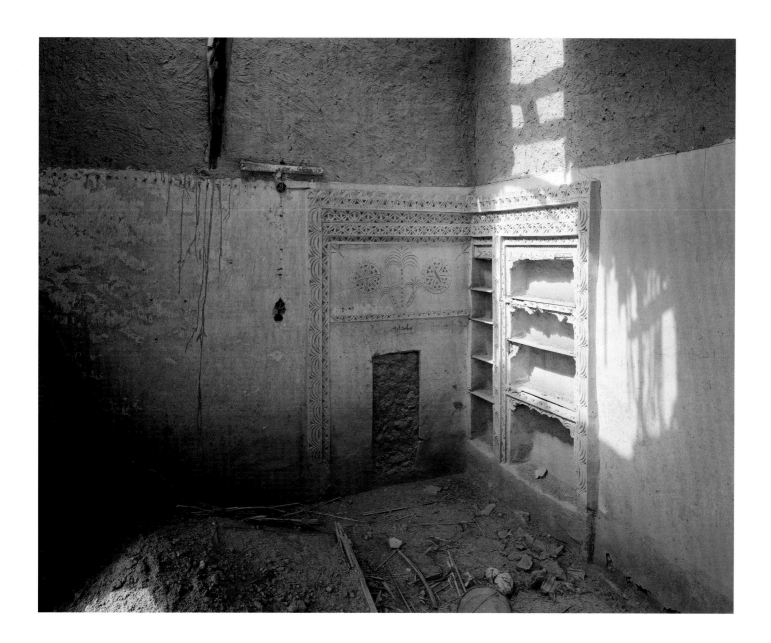

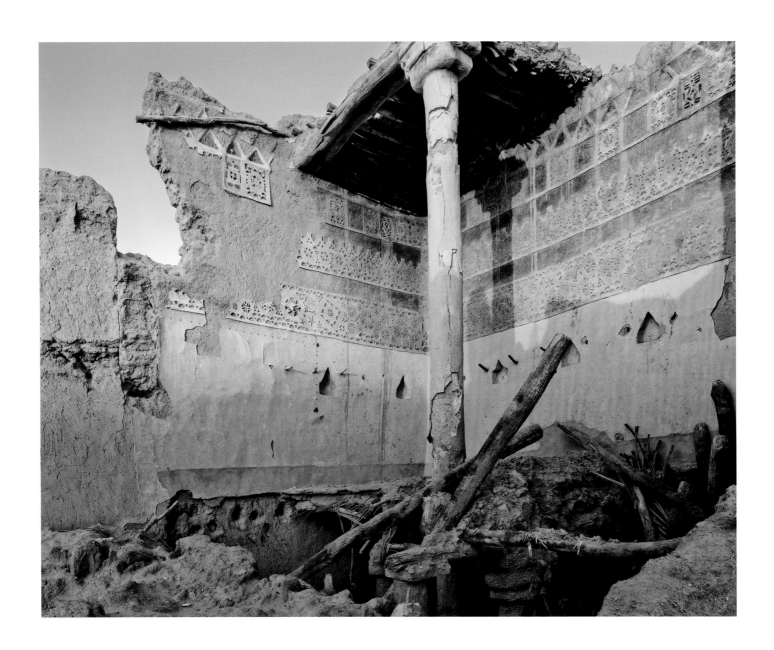

Mud house ruin. Marat.

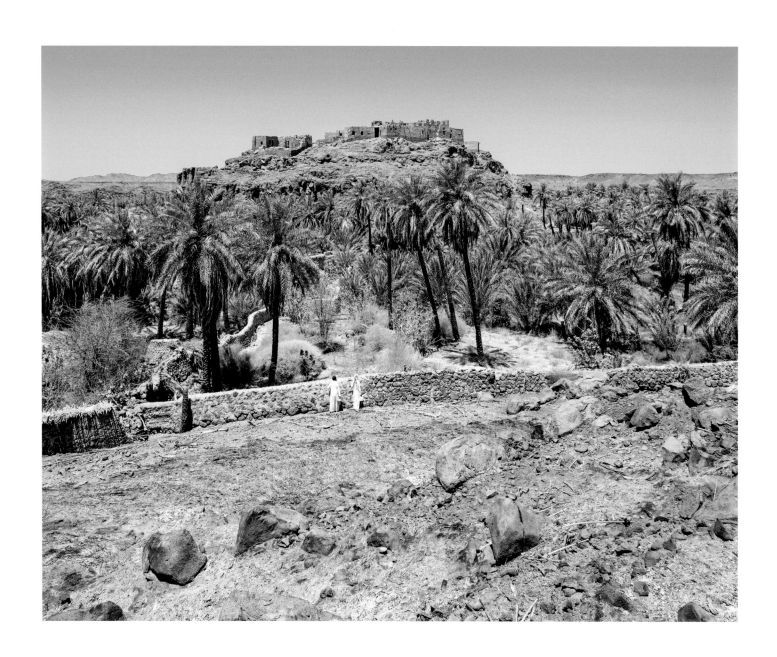

Abandoned fort in oasis. Khaybar.

Scars and Boundaries

New district. Al Amaaria.

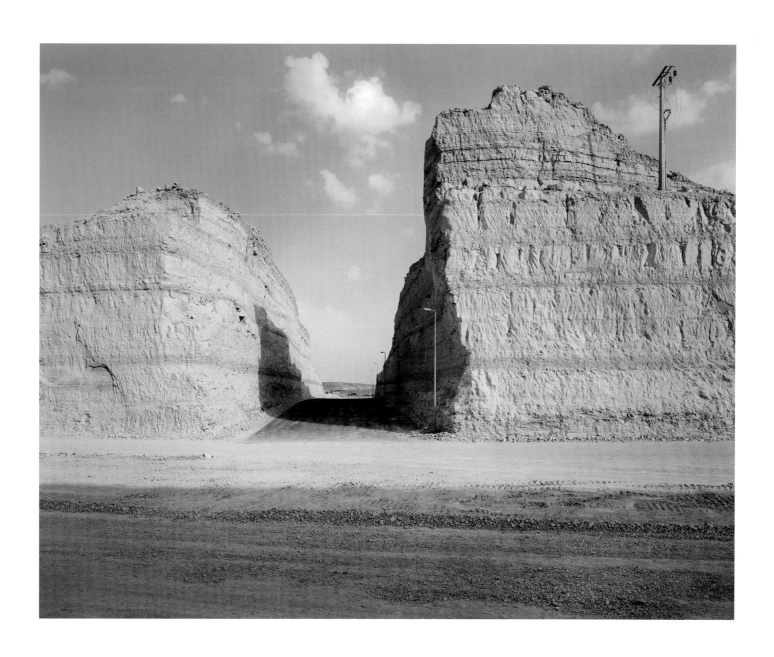

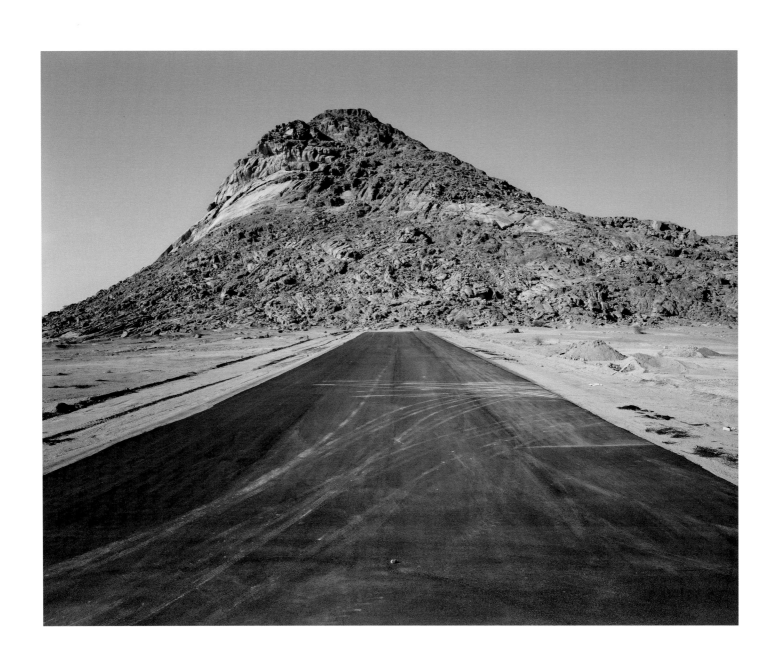

New road. Ar Ruwaidhah.

Excavation and wall. Riyadh.

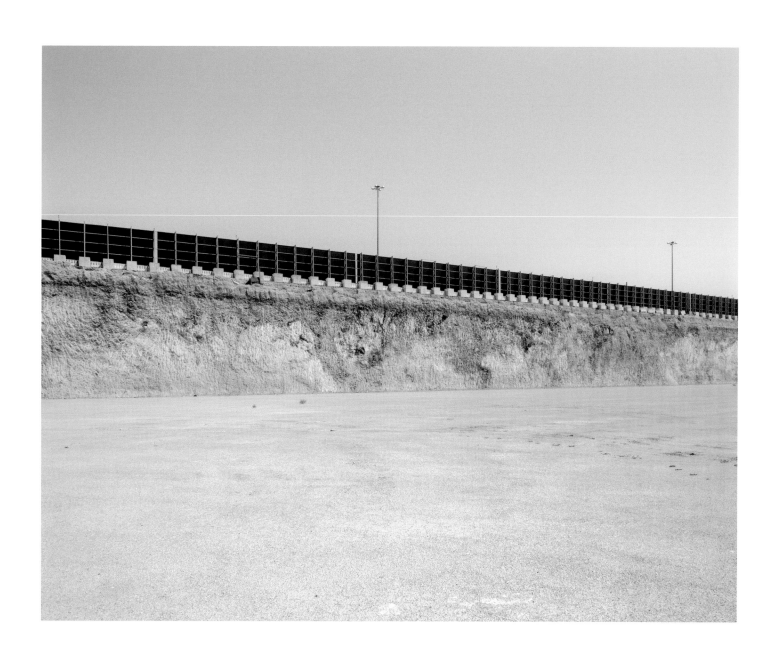

Earthworks. Ad–Dahna desert.

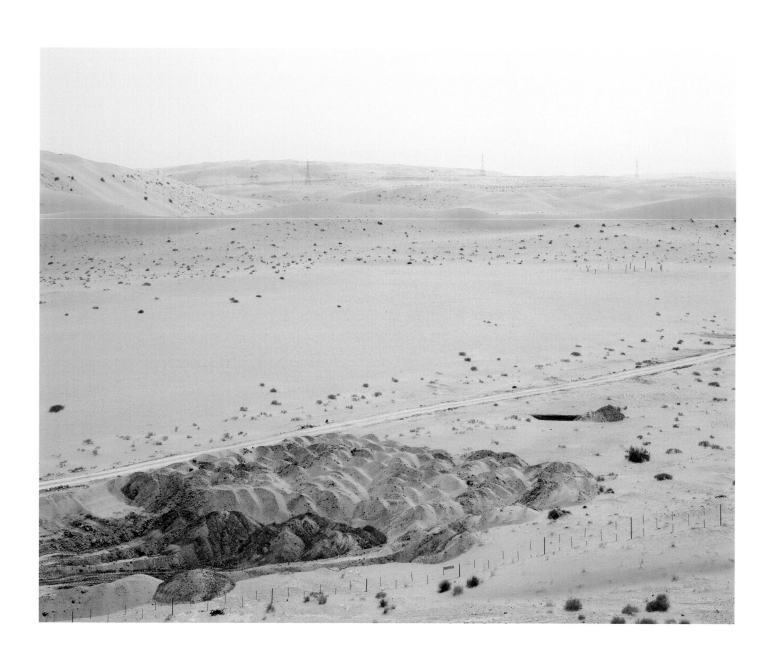

New road. Al Amaaria.

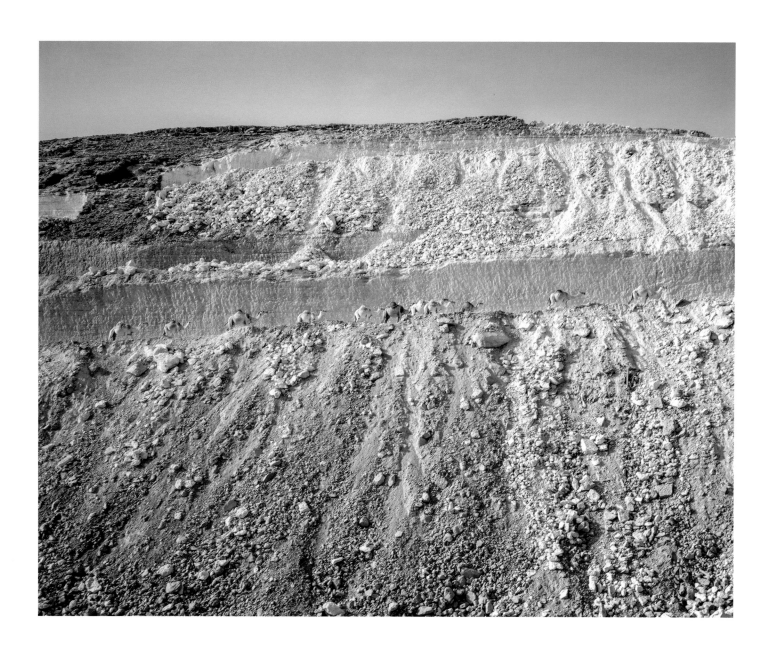

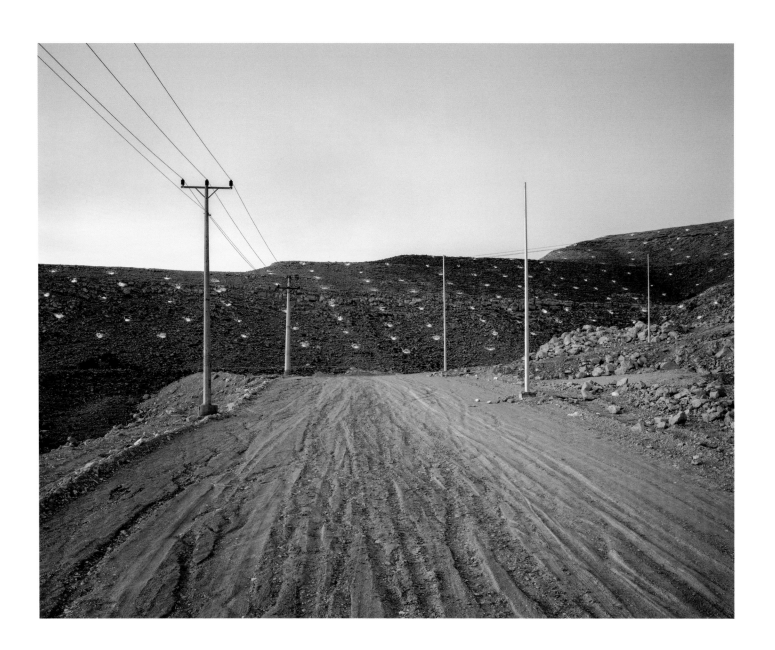

New development. Al Amaaria.

New settlement. Wadi Laban.

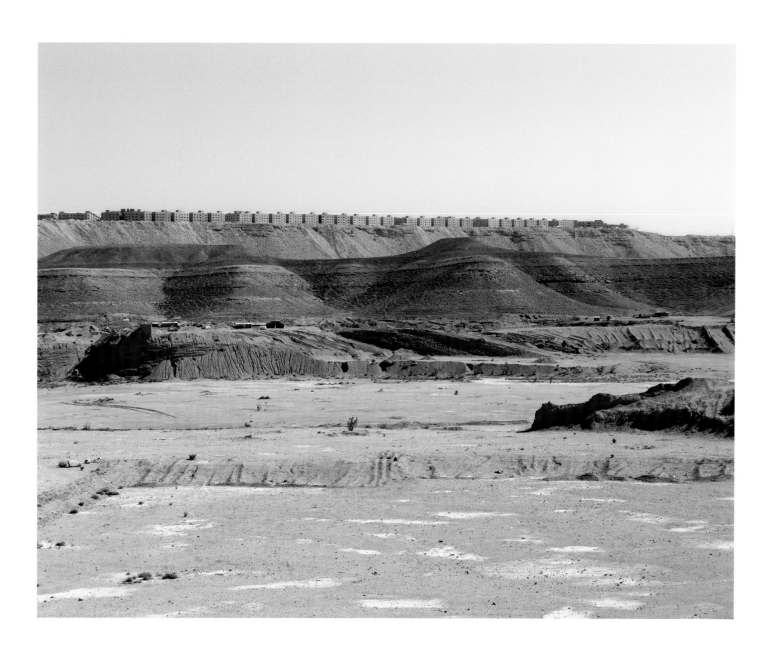

Excavation. Riyadh.

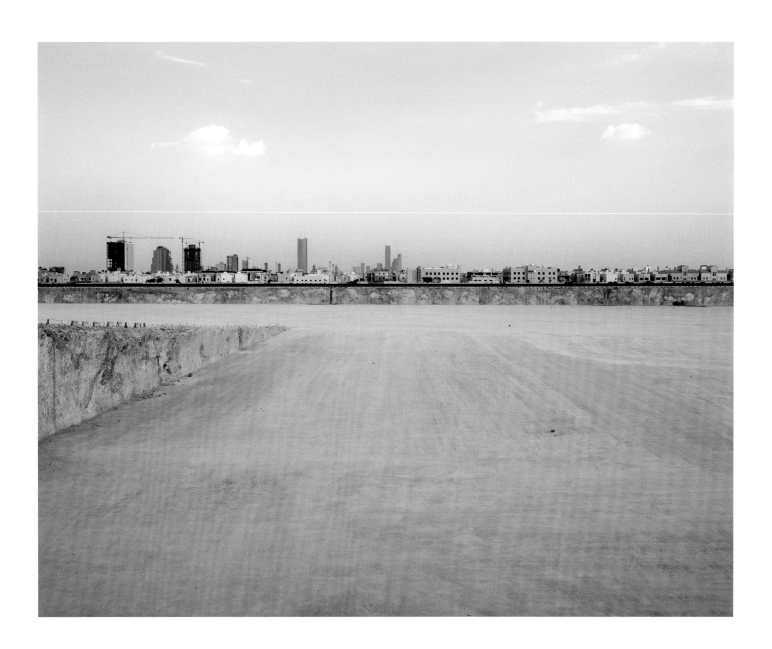

Excavation and construction. Riyadh.

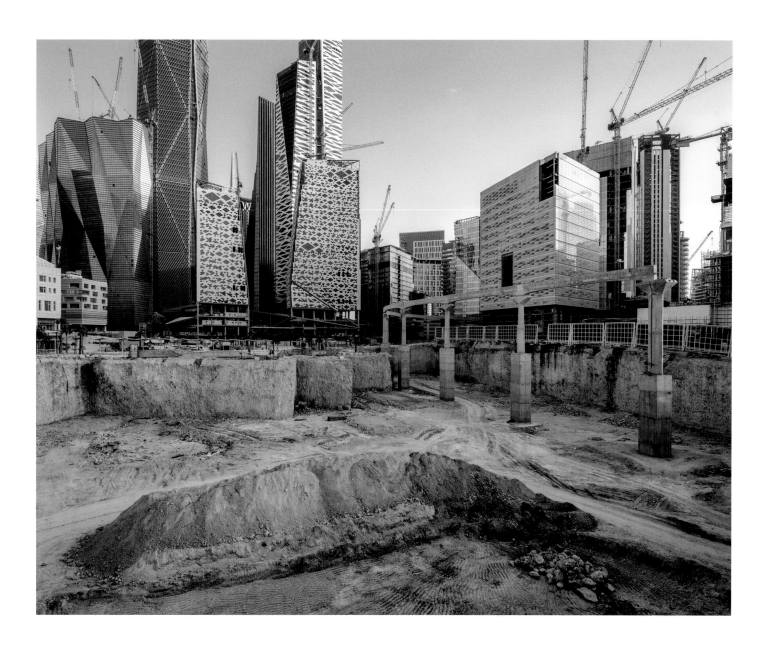

Holy Cities

Edge of Al Haram. Makkah.

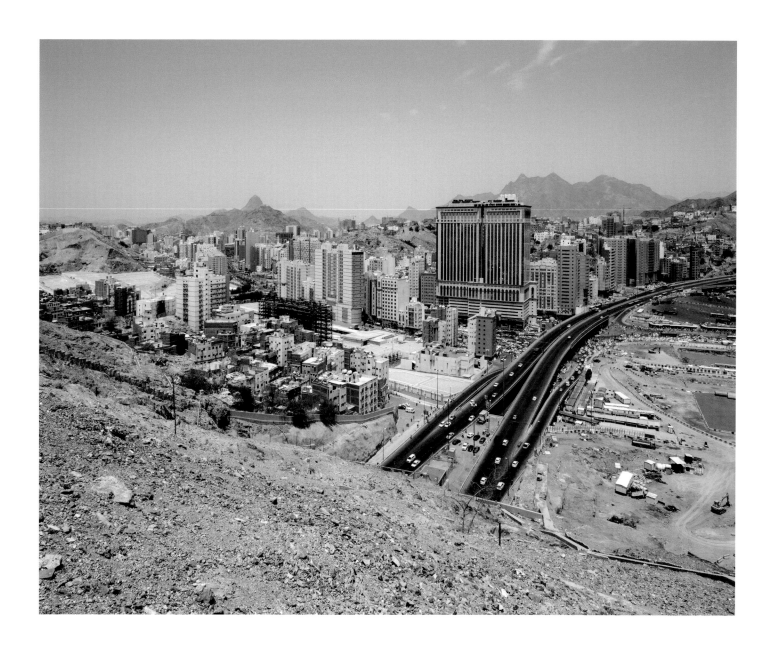

Mina Tent City. Makkah.

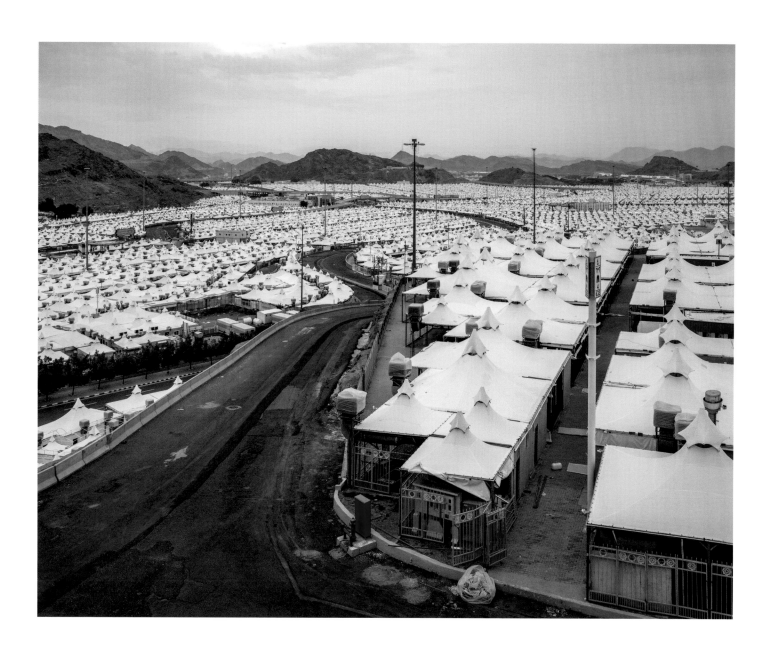

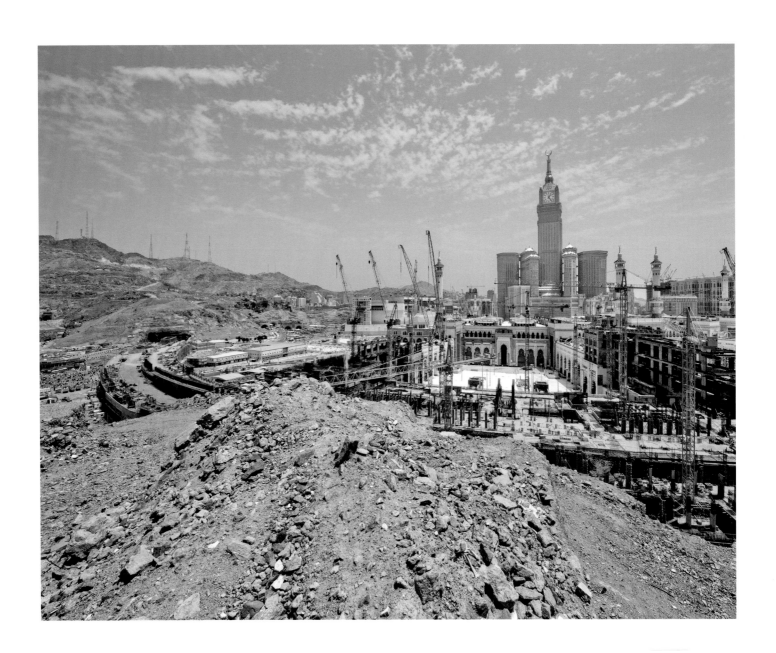

Expansion of the Al Haram Mosque. Makkah.

Kaaba. Makkah.

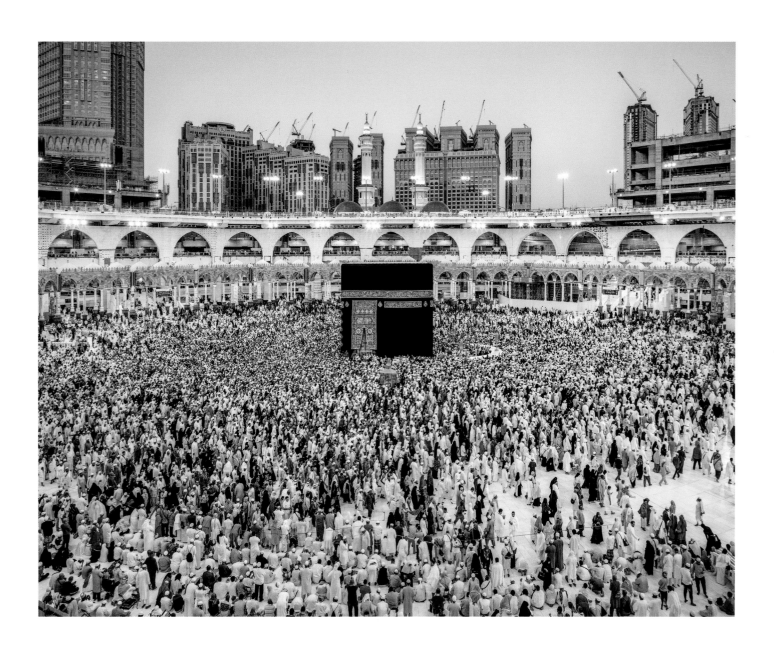

Hotel courtyard. Madinah.

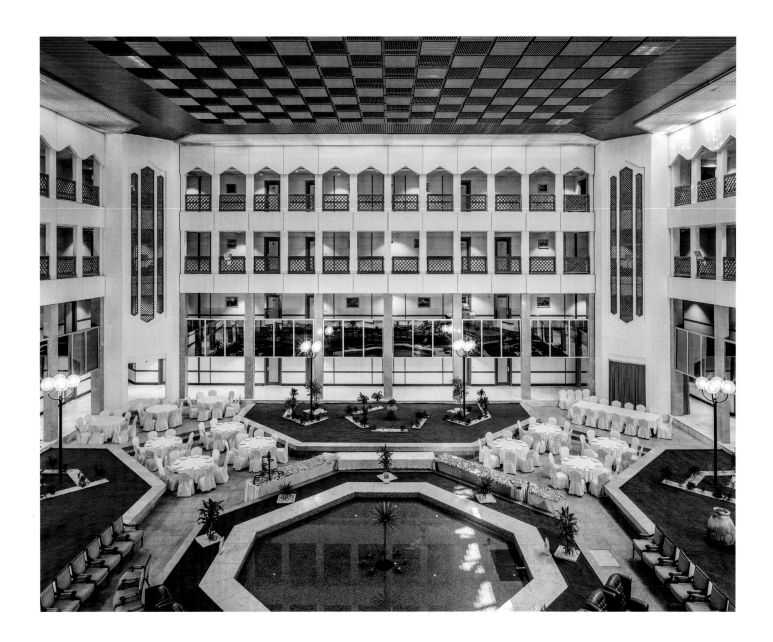

Informal settlement. Madinah.

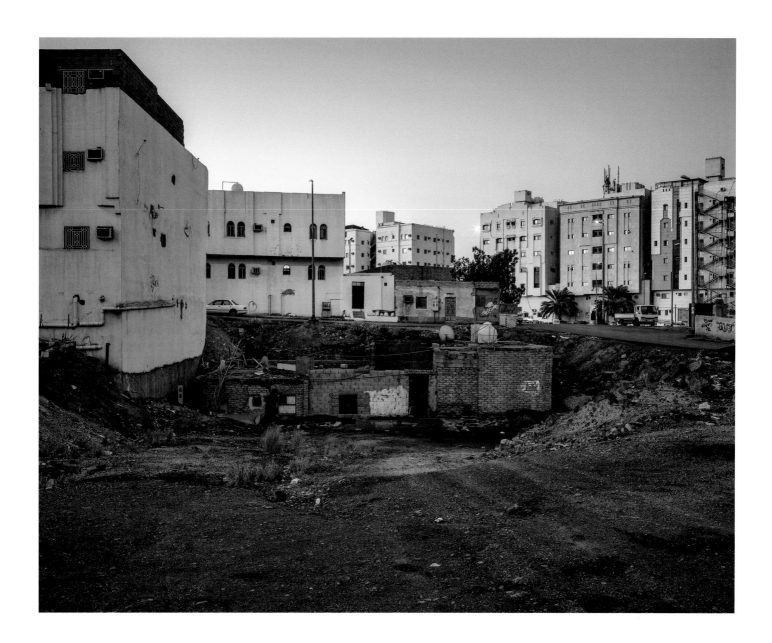

Al Usayfirin district. Madinah.

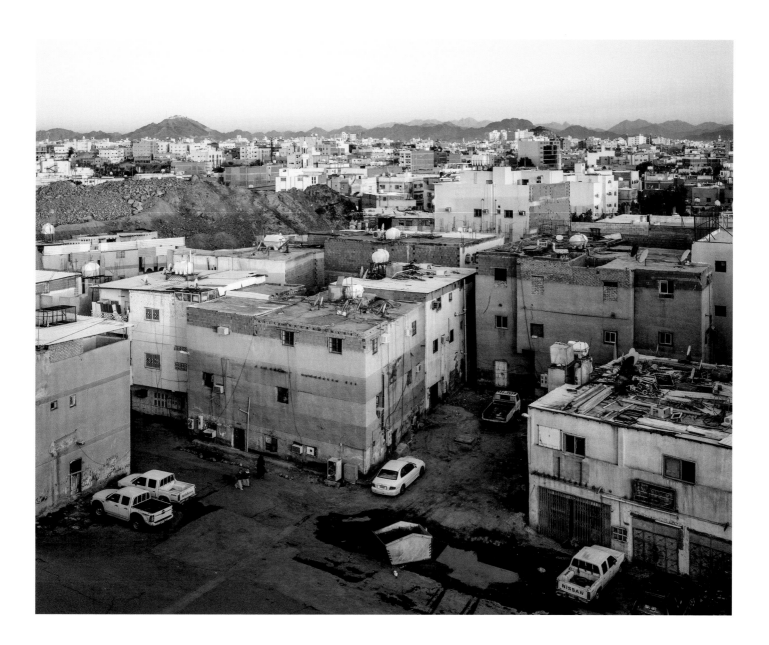

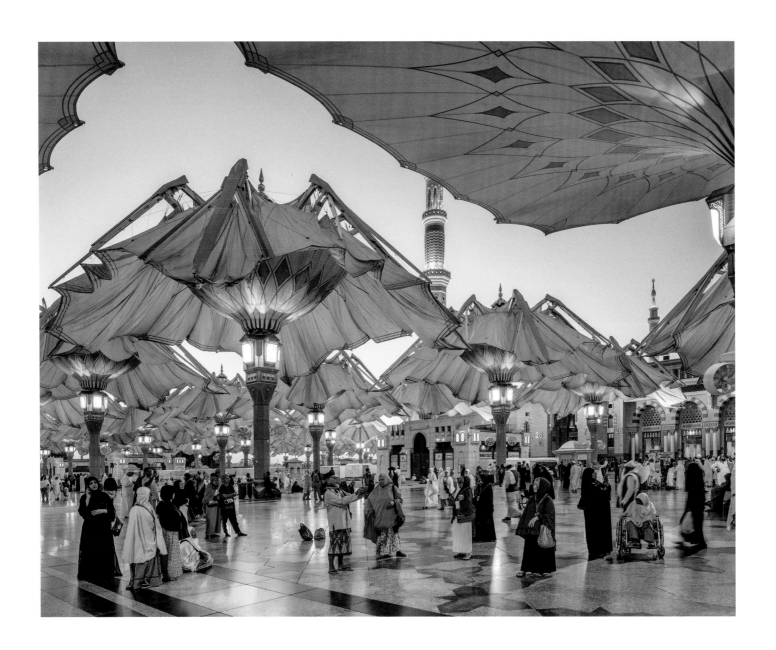

Al Haram and the Prophet's Mosque. Madinah.

Saudi Domain

Terraced farming community. Asir region.

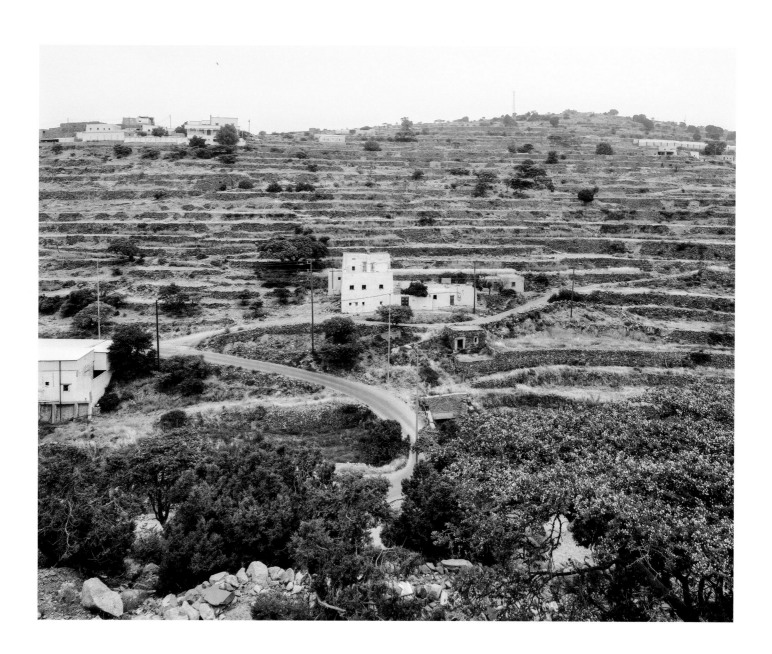

Mountain village of Rijal Alma. Asir region.

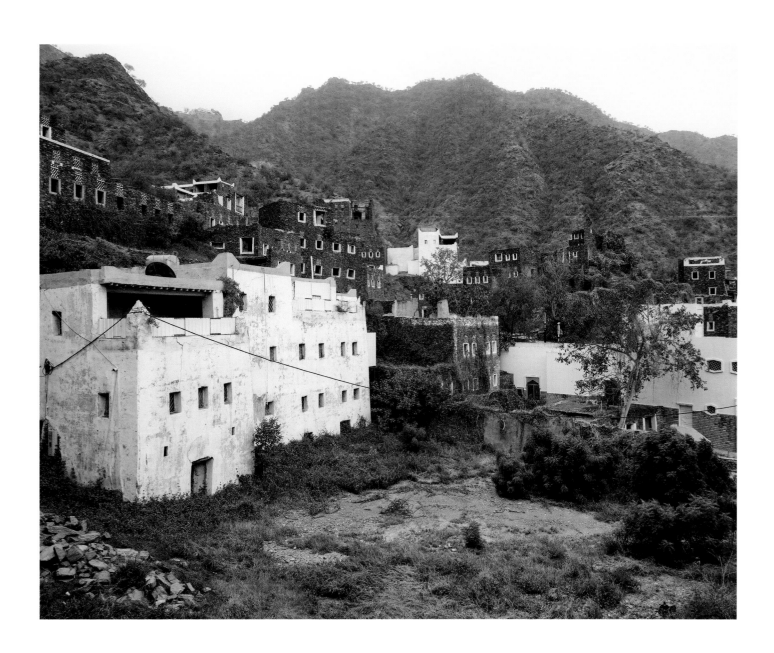

Old Dirah. Riyadh.

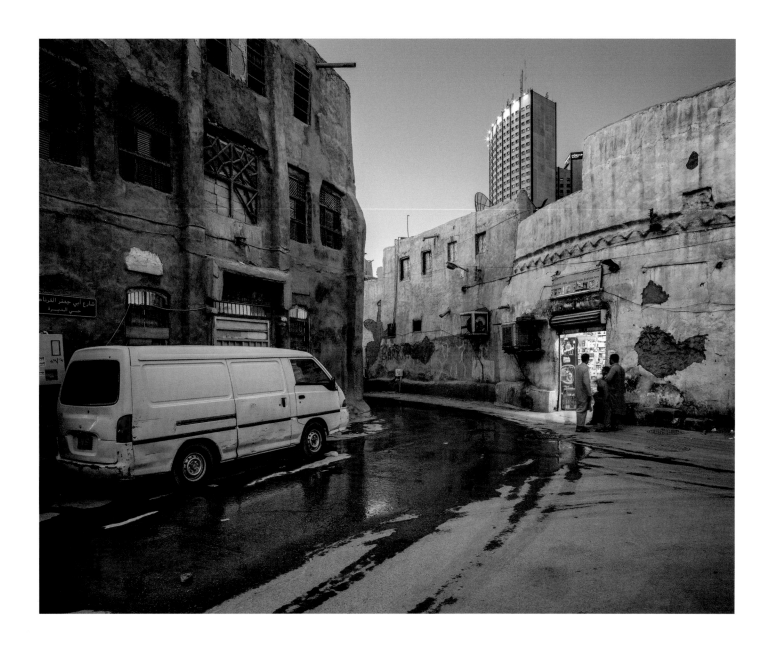

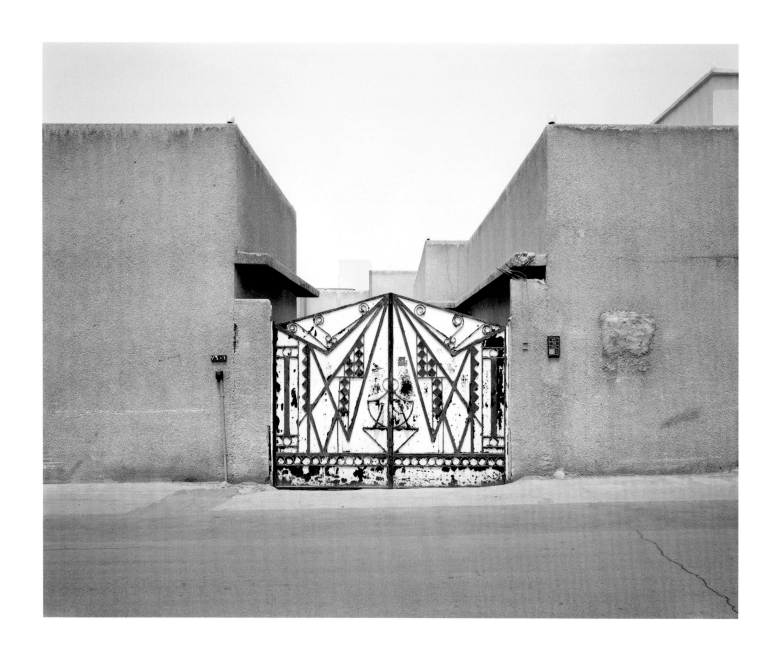

Old concrete building. Riyadh.

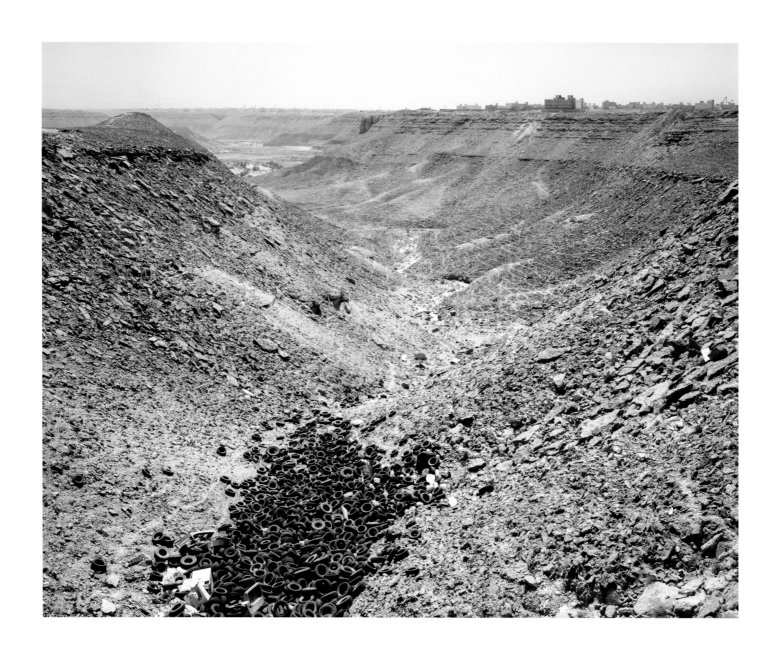

Ubayr district at the city's edge. Riyadh.

Farm. Wadi Laban.

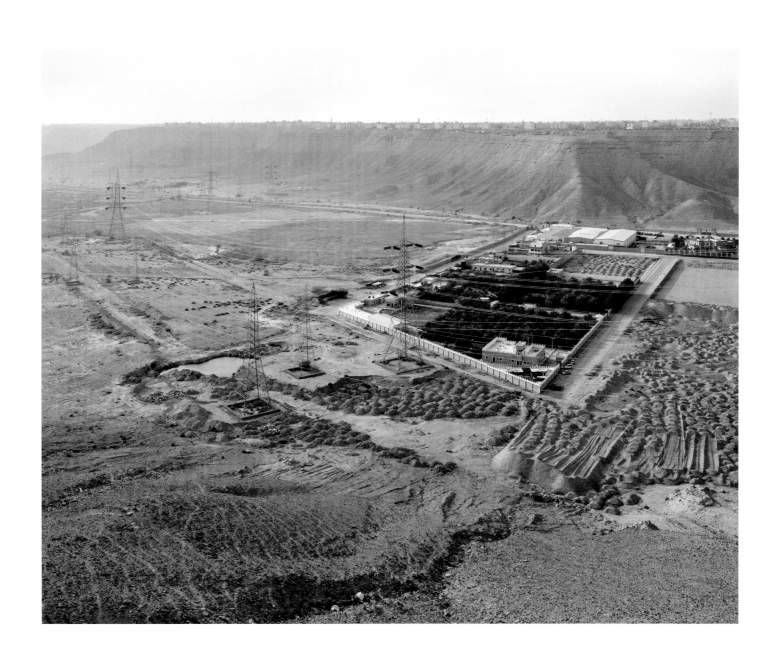

Eastern Ring Road bridge. Wadi Hanifah tributary.

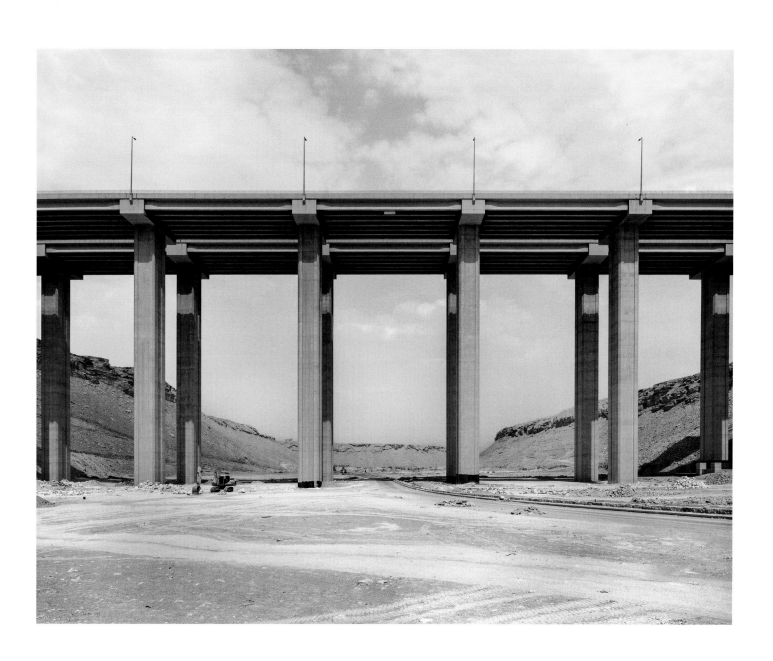

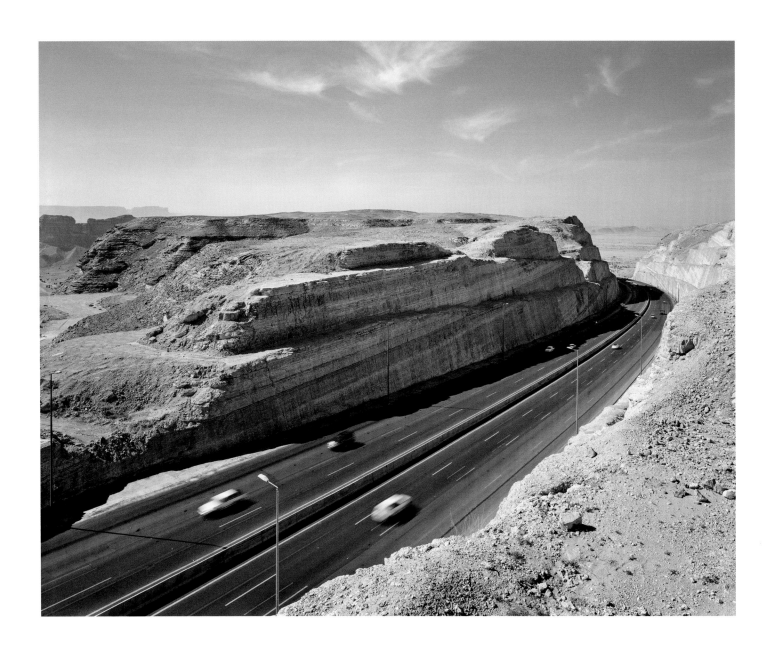

Makkah Road escarpment cut. Riyadh region.

New housing. Riyadh.

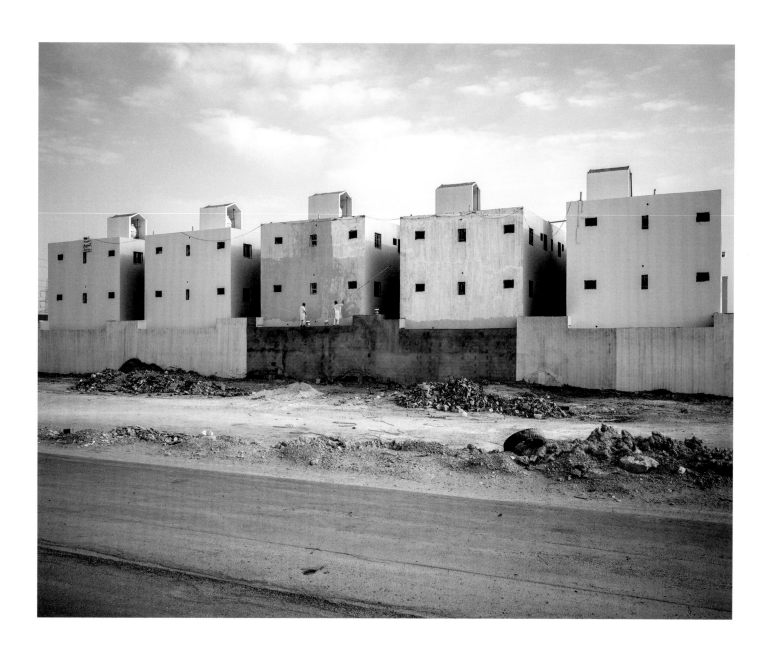

Olaya Road metro construction. Riyadh.

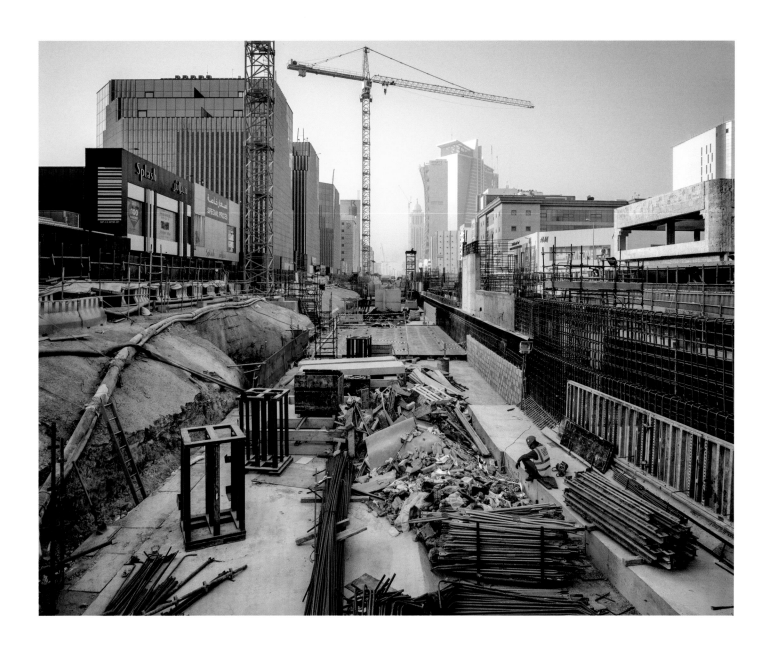

Kingdom Center Tower. Riyadh.

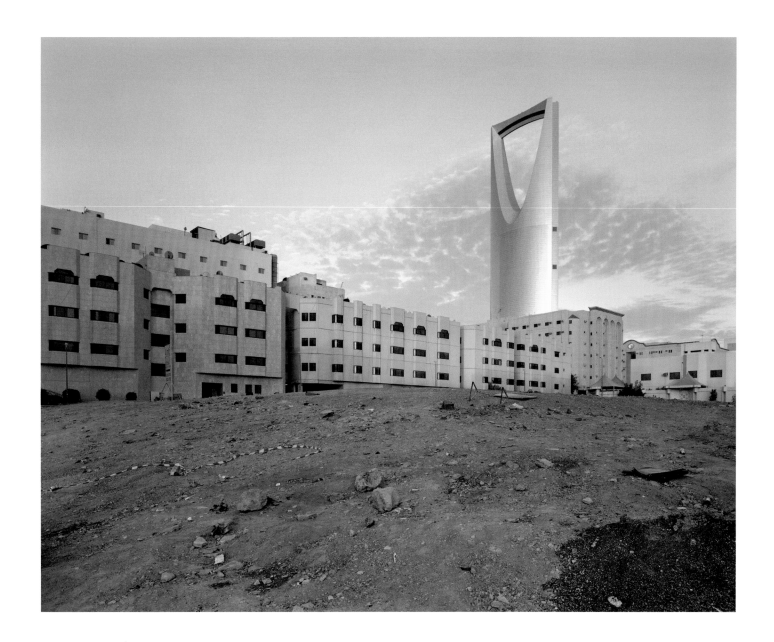

King Khalid Road interchange. Riyadh.

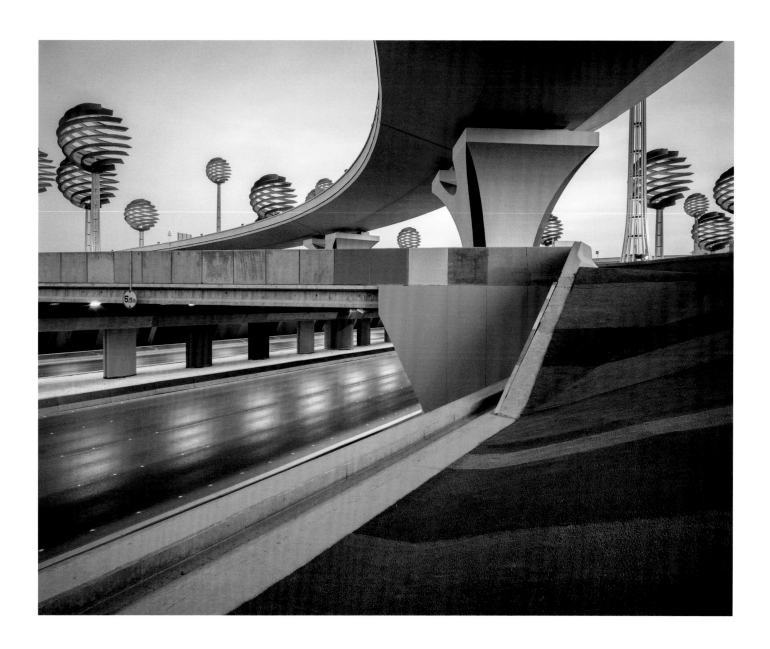

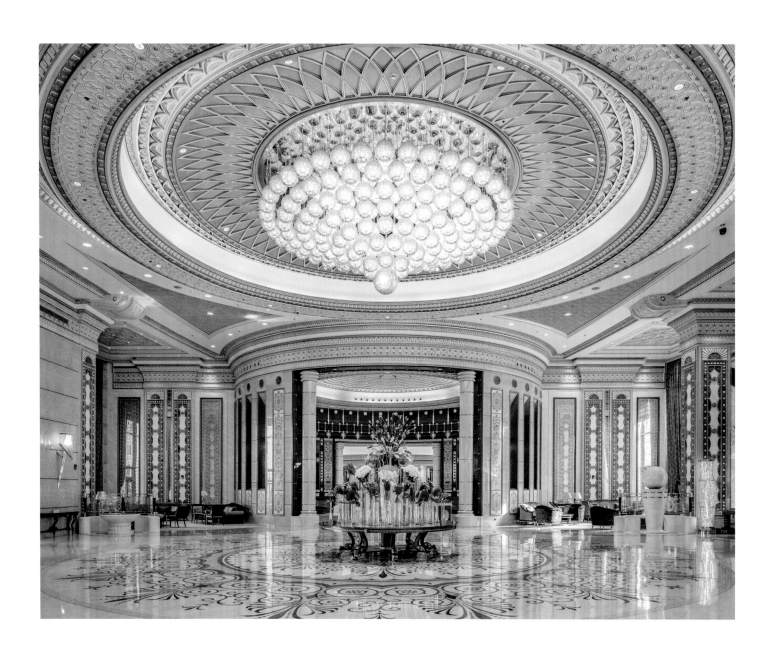

The Ritz-Carlton Hotel. Riyadh.

King Abdulaziz Center for World Culture Library. Dhahran.

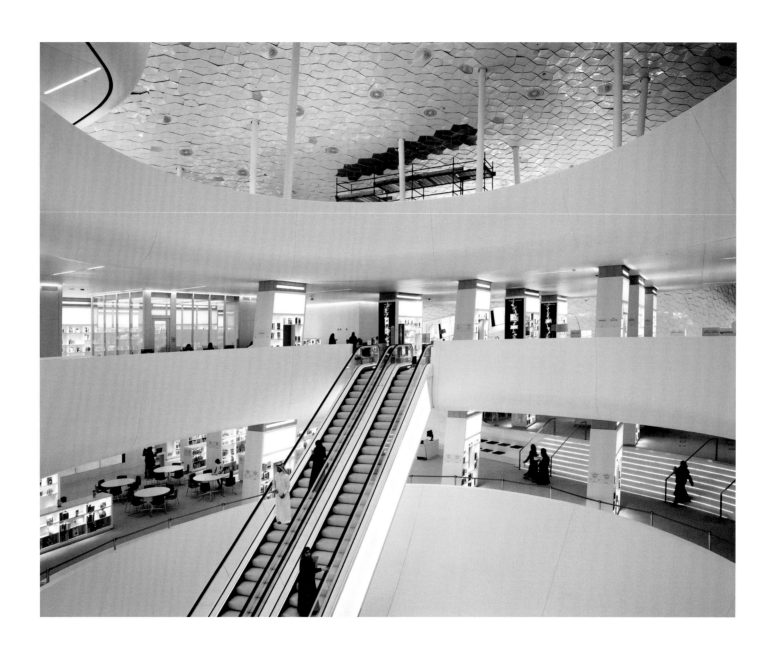

King Abdullah Financial District. Riyadh.

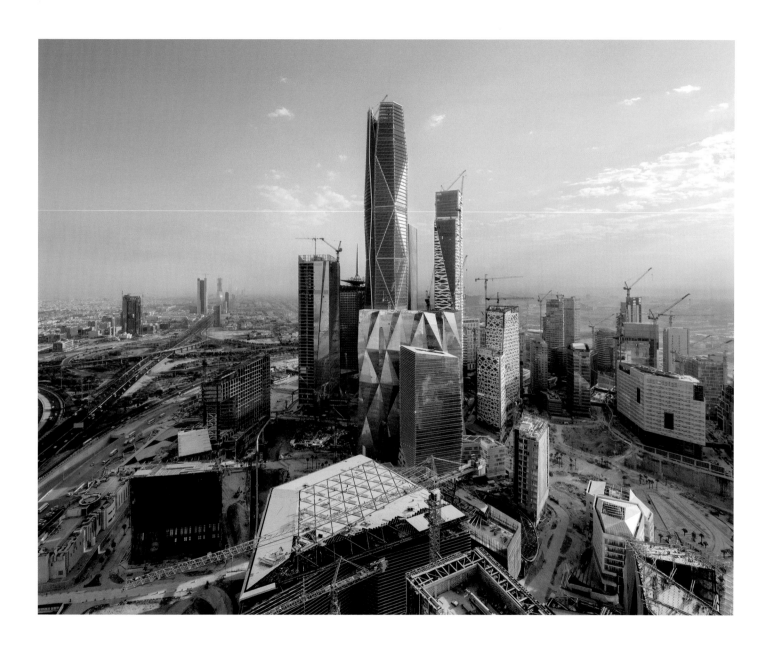

Desert People

Friends. Asir region.

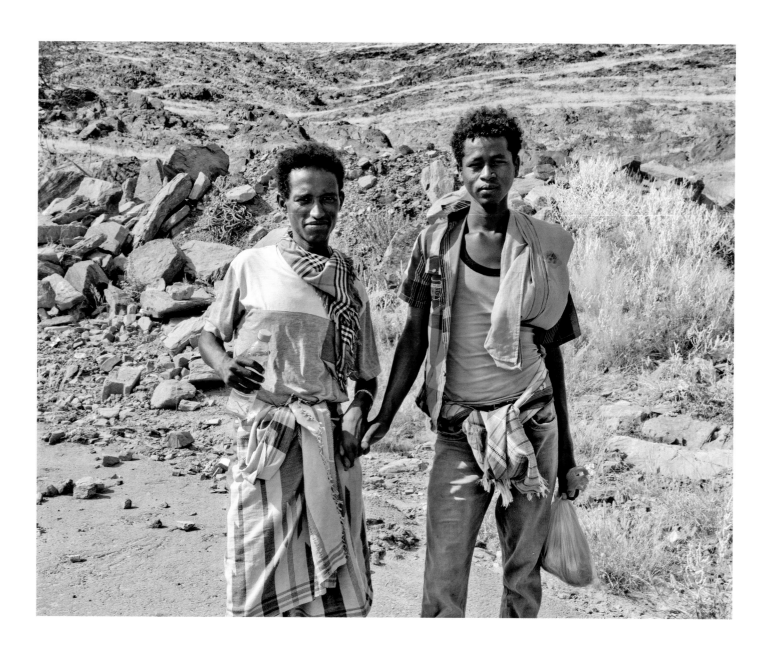

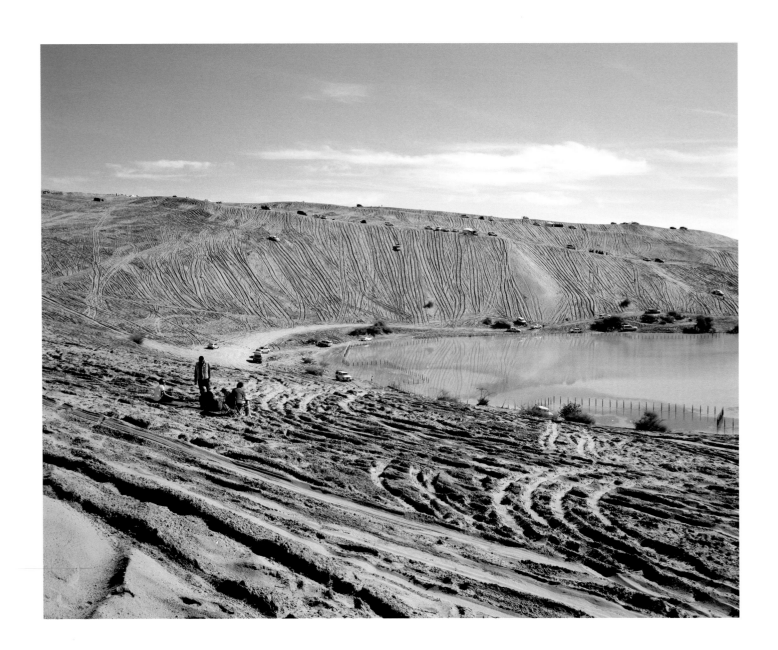

Spectators at Lake Kharrarah. Riyadh region.

Saudi youth. Asir region.

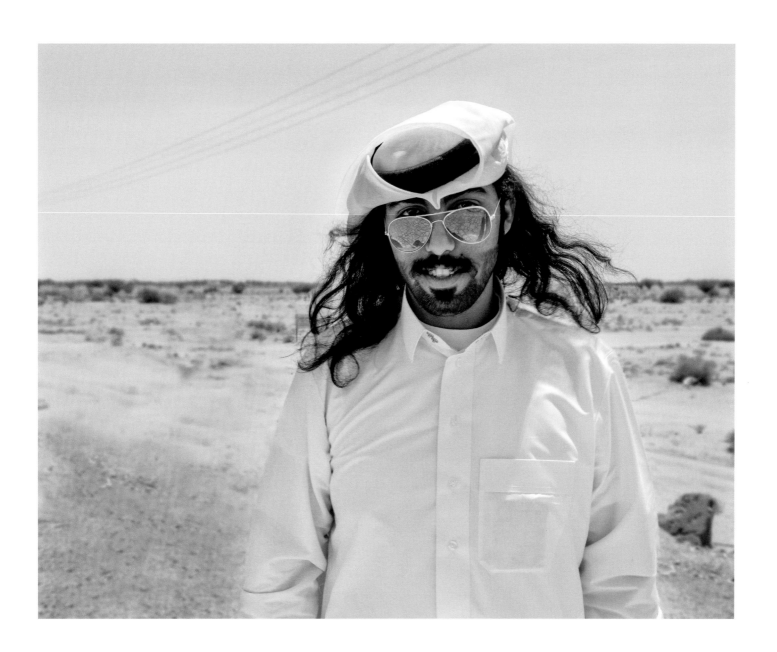

Womens' picnic at Masmak Fort. Riyadh.

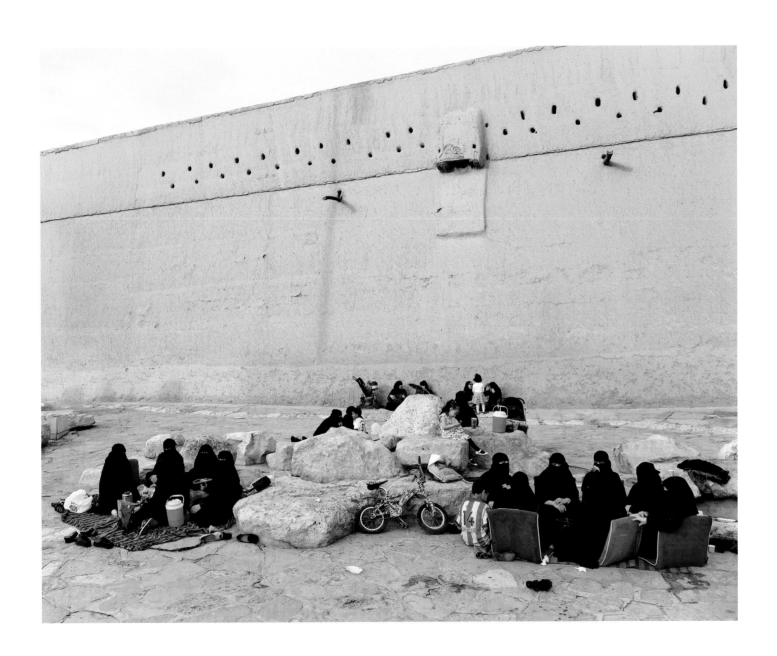

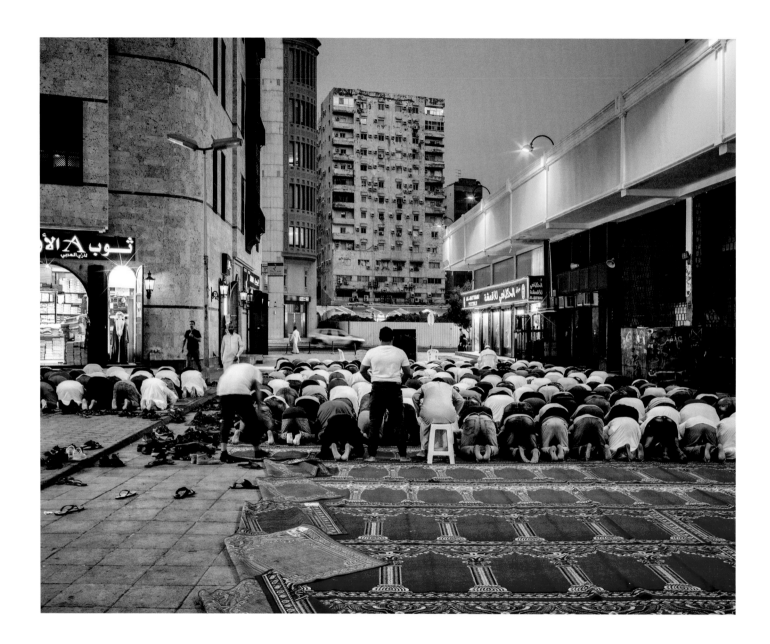

Worshippers in Al Balad. Jeddah.

Camel owner. Dhurma.

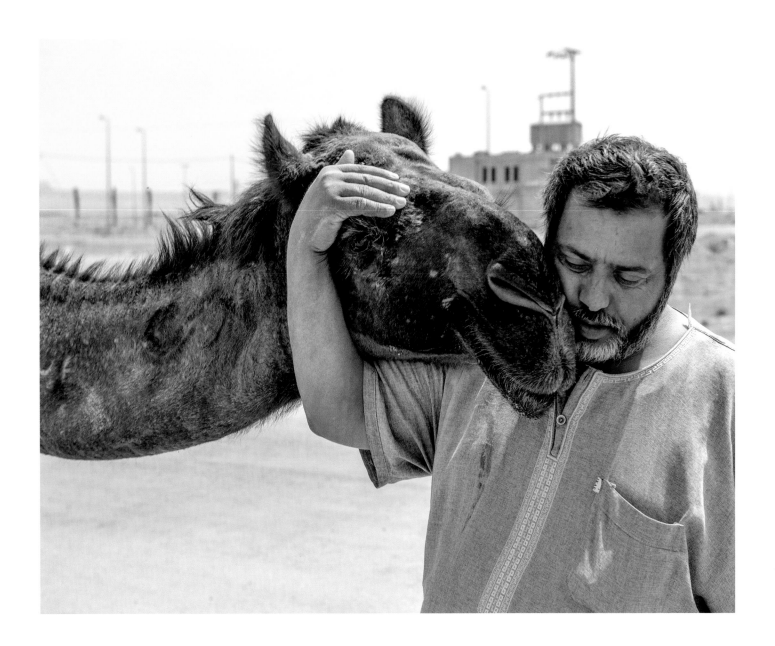

Construction site caretaker. Riyadh.

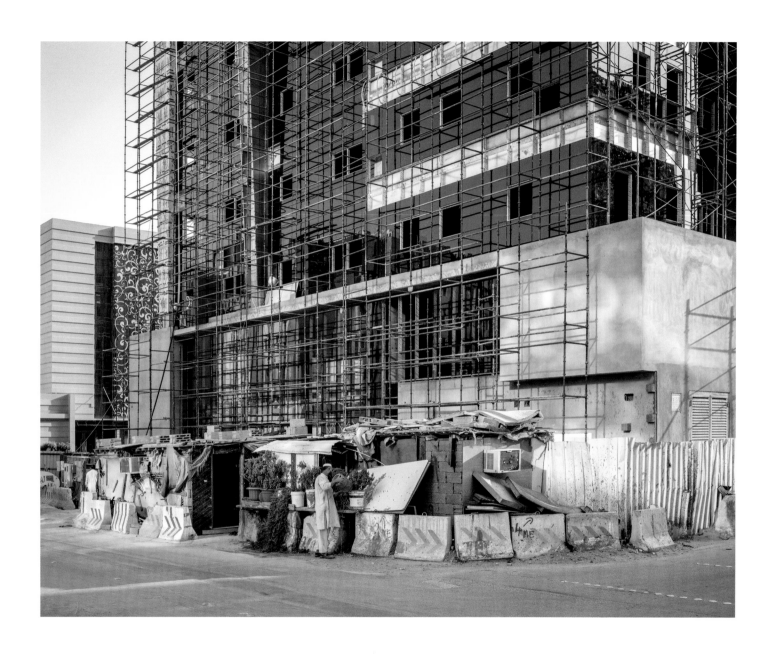

Worker. Riyadh region.

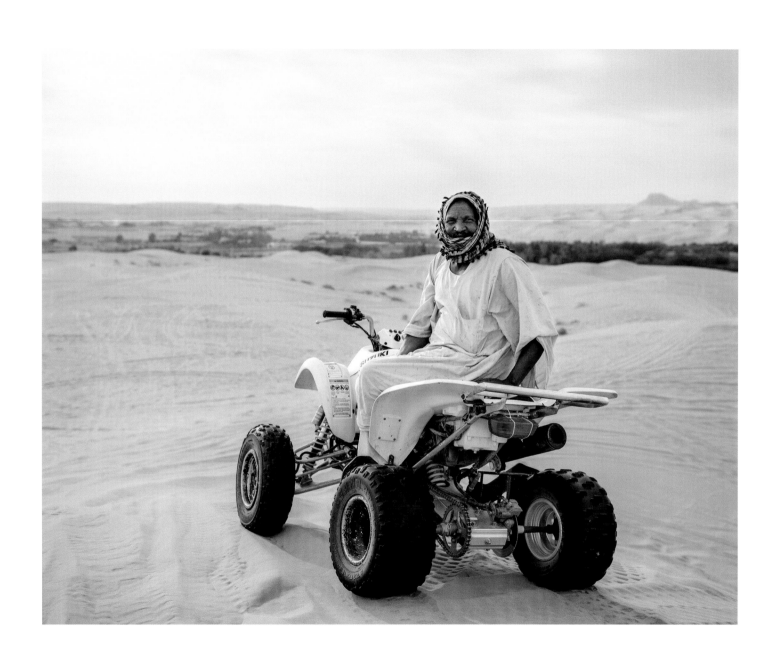

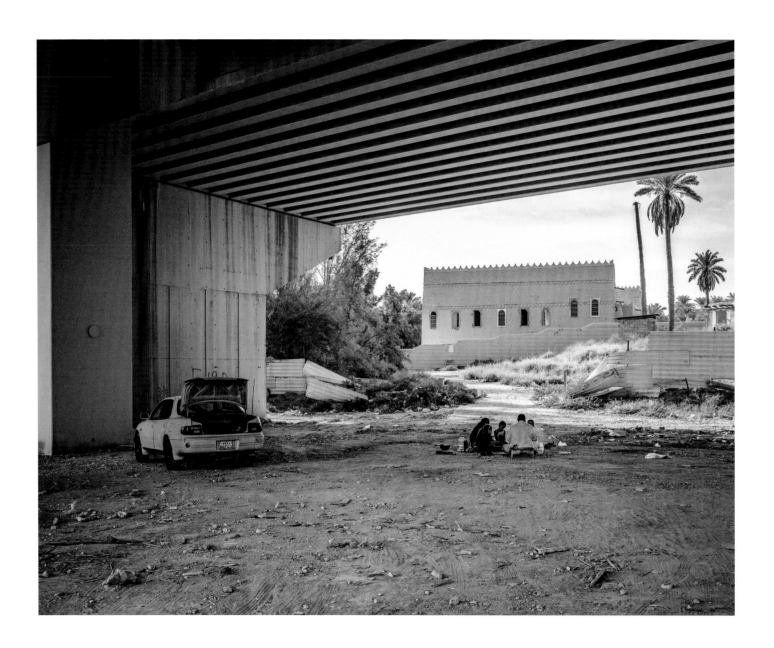

Family picnic under bridge. Wadi Hanifah.

Merchant. Makkah region.

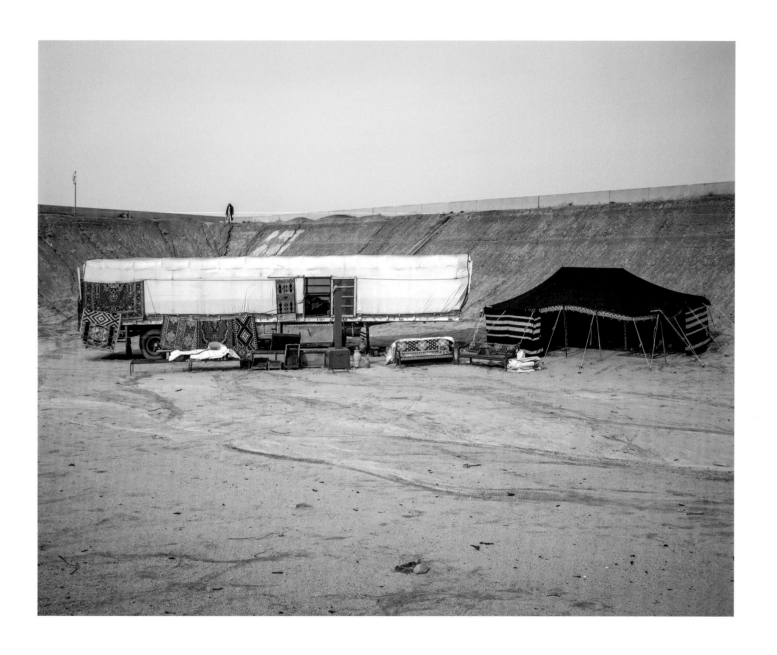

Explorers. Tuwaiq escarpment.

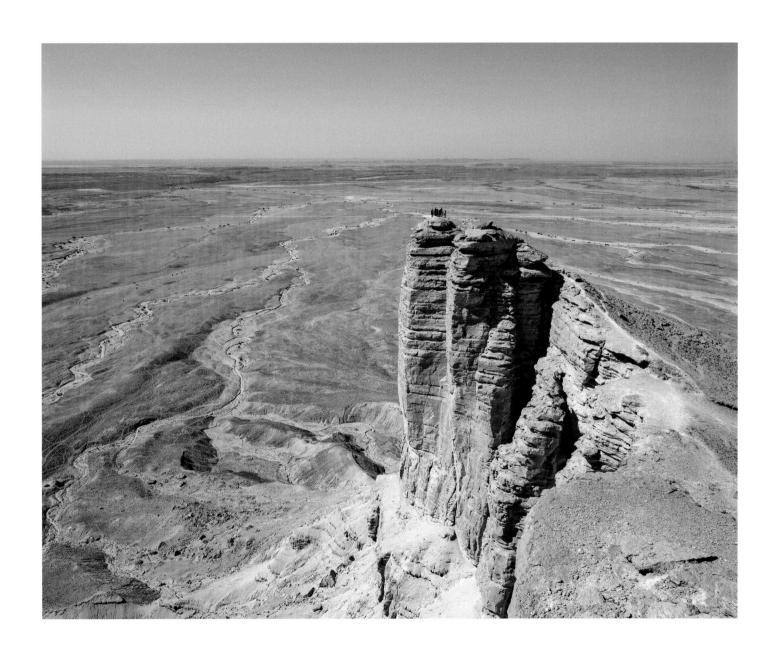

Selected Notes on the Photographs

Petroglyphs. Ad-Dahna desert.
The distant ancestors of Saudi Arabians left their traces at numerous sites around the Kingdom in petroglyphs and rock inscriptions, some dating back as far as 10,000 years. They speak to a long history of human inhabitation here, and some reveal a much different past of the land, depicting animals long extinct in the arid environment. These petroglyphs are nominally preserved with varied degrees of success; this site has been vandalized by drilling.

Petroglyphs. Jubbah.
The petroglyphs are like historical documents that disclose the foundations of a regional culture. The camel figures prominently in these carvings, setting the tone for that deep and time-honored relationship of codependence.

Mada'in Saleh. Madinah region.
Mada'in Saleh, also called Al Hijr, is the second-largest ancient settlement of the Nabatean civilization after Petra. It remains relatively unknown and remarkably well preserved because, historically, it has been isolated within the harsh Arabian Peninsula, and currently no formal tourism industry exists in Saudi Arabia.

Al Qarah Mountain caves. Al Hofuf.
The unique geology of Al Qarah Mountain offers numerous natural caves that were historically used as spaces for habitation and commerce. Part of the mountain cave system is now a local tourist attraction. Pictured here is an abandoned space that up until recently had served for celebrations, such as weddings.

Camel trail. Tuwaiq escarpment.
In the not-so-distant old days, the Tuwaiq escarpment posed a formidable challenge for the movement of camels and people across the Arabian Peninsula. A few zigzagging trails still remain, connecting the lower and upper plateau of Najd. But these days, the trails are no more than a picnic destination; just on the other side of the wall of rock in the photograph's background is a modern, high-capacity highway boldly cut out of the rock of the escarpment.

Abandoned settlement. Ushaiqer.
The rapidly disappearing physical traces of traditional Saudi heritage are starkly visible throughout the country. It is like a poetic simile that the Saudi neglect of their heritage is literally turning it back into sand. There is a new effort to preserve and restore some of these places, but in many instances, it is too little too late; the majority of the population still does not see the benefit of preserving its built past.

Old and new town. Al-Ula.
Like many traditional Saudi towns, this one grew around a fertile oasis and remained unchanged for much of its existence. But as government-subsidized modernizing measures begun in the 1950s—as in the countless other traditional towns—this old town was abandoned for the comforts of modern, concrete buildings built simply a few metres away. The contrast is as stark as it is symbolic of neglect (and near loss) of a national heritage.

Abandoned mud building. Dirah.
A traditional courtyard building in the historic core of Riyadh, assembled from mud, stacked stones for columns, palm fronds for flooring, and sparsely available wood for horizontal supports. Although rudimentary, these buildings offered many innovative responses to living comfortably and sustainably in the harsh desert climate. Not much effort is made to preserve

these structures or learn from the sustainable ways of the past. Since this photograph was taken in 2014, half of the building collapsed due to neglect.

Mud house interior. Marat.

At the heart of the traditional Saudi community is a Majlis, which is a central sitting place where gatherings occur to discuss local events and issues, exchange news, receive guests, socialize, and be entertained. On the larger scale, these were buildings within the community, and on the domestic scale, they were central rooms in a household. Here is a modest domestic Majlis with its characteristic decorative corner, abandoned for more comfortable accommodations.

New district. Al Amaaria.

Modern development in Saudi Arabia suffers from a disregard for the past and the environment in an urgent effort to leave behind what is seen as unsophisticated. Ironically, many of the modernizing measures are unsophisticated in themselves, creating lasting scars on the landscape.

Excavation and wall. Riyadh.

The scale of many developments is massive and, in some cases, unprecedented. It speaks to the unique subcontext of a steady supply of cheap labor fueled by huge financial resources, all derived from oil wealth.

Edge of Al Haram. Makkah.

Makkah is faced with extraordinary development pressures. It is a city of unmatched importance, being the home of Islam and the place of the Kaaba. Its resident population is roughly 1.6 million, but that number more than doubles (in 2012 it tripled) for a couple of weeks every year during the Hajj pilgrimage. Adding to this, Makkah is located within a confined mountainous terrain, making it densely crammed in a way and scale that is unparalleled.

Mina Tent City. Makkah.

The Tent City of Mina covers 20 square kilometers (7.7 square miles) and is located just east of the Al Haram Mosque in Makkah. It contains more than 100,000 permanent tents capable of temporarily housing over three million pilgrims during the Hajj pilgrimage. For the remainder of the year, the Tent City is empty. Makkah is a remarkable place where massive-scale urban development is dictated not so much by urban principles as by religious principles.

Expansion of the Al Haram Mosque. Makkah.

The Al Haram Mosque cannot keep up with the demand of pilgrims wanting to perform their religious duties on its ground. It is now in a constant state of expansion and a complex crowd and construction management takes place there, as both are occuring in the same space at once. The immense pressure on the Holy Mosque to expand is witness to old districts around it being cleared and mountains raised to greatly enlarge its capacity. In Makkah, as in Madinah, the immediate vicinity of the Two Holy Mosques is unrecognizable to what it was even twenty years ago.

Al Haram and the Prophet's Mosque. Madinah.

The Al Haram plaza of the Prophet's Mosque is both impressive and unique. As in Makkah, this is a very important site for Islam as it contains the burial place of the Prophet Muhammad, and hence attracts millions of visitors yearly with the main influx occurring during the Hajj pilgrimage. Here, too, extraordinary development pressures result in extraordinary solutions. The mechanical folding umbrellas protect the crowds of faithful against the harsh sun. The structures are like mechanical flowers, opening at the break of dawn and closing at dusk. Watching hundreds of these structures do so in unison is a daily breathtaking spectacle.

Terraced farming community. Asir region.

Parts of Saudi Arabia are different in character than the desert-like environment covering its majority. This is especially so for the

Asir region in the mountainous southwest, along the border with Yemen. Here, life remains much more pastoral and traditional, with whole villages seeming like they are in an earlier time with their heritage fully intact. This is a poorer region than that of central Arabia, but perhaps better equipped to make a smooth transition to modernity.

Old concrete building. Riyadh.
Traditional homes were constructed to be private and inward looking, with imposing walls and gateways, and few, if any, screened windows or light openings to the outside. This was extended to the early building made of concrete. Here, only the artful gateway design gives a hint of a less austere life within.

Ubayr district at the city's edge. Riyadh.
As the city rapidly expands outward, covering the plateaus and cutting and filling hills and valleys, the landscape suffers from neglect as a consequence of the rapid progress.

Eastern Ring Road bridge. Wadi Hanifah tributary.
Large infrastructure projects are a common sight throughout the Kingdom. These structures and the accompanying disruption to the landscape present a stark contrast to the often-underdeveloped settings they are in.

Olaya Road metro construction. Riyadh.
While many rapidly growing cities are investing in incrementally implemented mass transit systems, only Riyadh is constructing the largest metro project in the world, with a total route length of 176 kilometers (109 miles), all being built at once. Such mega projects are the norm in a place where money is of little concern.

Kingdom Center Tower. Riyadh.
Progress in the Kingdom is a fluid concept and one often comes across the jarring juxtaposition of modern skyscrapers adjacent to underdeveloped and neglected land.

The Ritz-Carlton Hotel. Riyadh.
Otherwise known as the King's Royal Guesthouse, this is the luxury hotel made infamous by serving as a jail for royal family members and business leaders suspected of corruption in a 2017 nationwide purge. Its display of luxury is typical of the grandiose aspirations of the Kingdom, and ironically, its choice as jail in some way symbolic of the temptations of corruption.

Spectators at Lake Kharrarah. Riyadh region.
For the Saudis, there is no greater joy than getting out into the desert. Modern times might have changed the means and the activities, but the attraction is as deeply rooted as ever. Just about everybody, young and old, rich and poor, enjoy driving their cars to the highest-most points of the tallest of sand dunes and, as their ancestors would have done on camels, engage in thrilling car rides to the bottom.

Womens' picnic at Masmak Fort. Riyadh.
Masmak Fort is the site where Abdul Aziz al Saud retook Riyadh in 1902, beginning his thirty-year civil war to create the modern Saudi State in 1932. As one of the few celebrated and preserved remnants of the past in Riyadh's historic center, Dirah, its surroundings are a popular place for families to sit, eat, and relax, as there are far too few public spaces elsewhere in the city.

Family picnic under bridge. Wadi Hanifah.
In Saudi culture the idea of a tended public space is a fairly new concept. It is not uncommon to see families picnicking on the side of a highway, in a littered environment, or under a bridge.

Cofounders: Taj Forer and Michael Itkoff
Copy Editor: Nancy Hubbard

© 2019 Daylight Community Arts Foundation

Photographs © 2019 by Peter Bogaczewicz

Foreword © 2019 by Edward Burtynsky
"Saudi Arabia: Tradition and Transition" © 2019 by Karen Elliott House
"Spaces of Memory and Imagination" © 2019 by Rodrigo Orrantia
Selected Notes on the Photographs © 2019 by Peter Bogaczewicz

ISBN: 978-1-942084-72-3

First Printing

Printed by OFSET YAPIMEVI, Turkey

Daylight Books
E-mail: info@daylightbooks.org
Web: www.daylightbooks.org